To!

New Hampshire
Women Farmers

Leslie Tuttle

Helen Brody

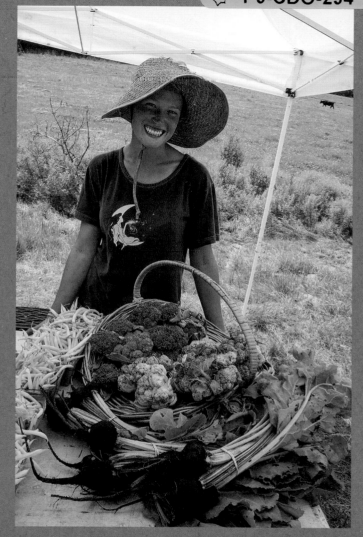

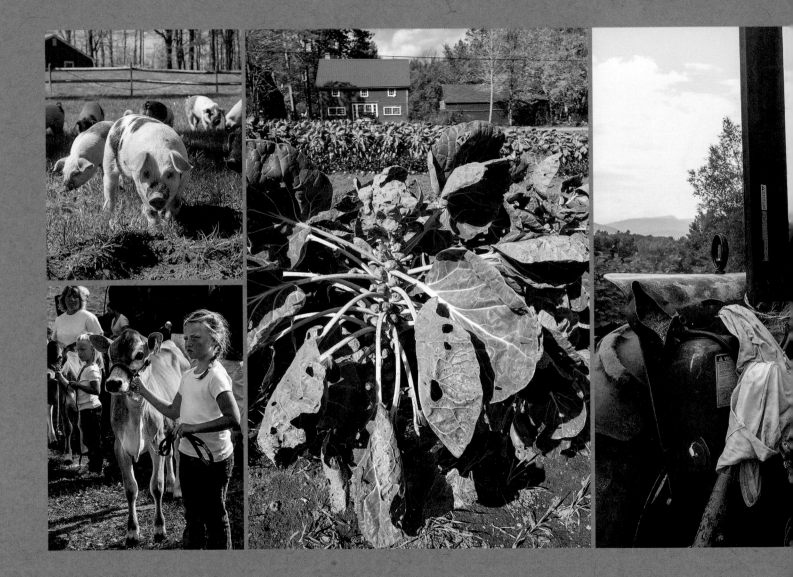

Helen Brody ⁓ Photographs by Leslie Tuttle

New Hampshire Women Farmers

PIONEERS OF THE LOCAL FOOD MOVEMENT

University Press of New England Hanover and London

University Press of New England

www.upne.com

© 2015 University Press of New England

All rights reserved

Manufactured in the United States of America

Designed by Mindy Basinger Hill

Typeset in Adobe Caslon Pro

For permission to reproduce any of the material in
this book, contact Permissions, University Press of New England,
One Court Street, Suite 250, Lebanon NH 03766;
or visit www.upne.com

Library of Congress Cataloging-in-Publication Data

Brody, Helen, author.

New Hampshire women farmers: Pioneers of the local food
movement / Helen Brody; photographs by Leslie Tuttle.

 pages cm

Includes bibliographical references.

ISBN 978-1-61168-784-2 (pbk.: alk. paper) —

ISBN 978-1-61168-785-9 (ebook)

1. Women in agriculture—New Hampshire.

2. Women farmers—New Hampshire. I. Title.

HD6077.2.U62N43 2015

338.1082'09742—dc23 2014048147

5 4 3 2 1

Page i Brookford Farm, Canterbury

Previous page Donna Sprague, Huntoon Farm, Danbury

HELEN DEDICATES THIS BOOK
TO HER FATHER, JAMES HAMILTON OWENS, JR.,
for giving her a childhood memory
of a well-composted vegetable garden.

TO HER MOTHER, HELEN NIXDORFF OWENS,
for recognizing and teaching her the importance
of well-prepared, locally grown food.

LESLIE DEDICATES THIS BOOK
TO CHARLES E. MERRILL, JR.,
for his generous support and for a lifetime
of guidance, inspiration, and friendship.

Contents

Women ⁓ *Off-the-Farm Support*

Foreword

I LEARNED ABOUT New Hampshire's first-in-the-nation ranking for women farmers in the 2002 Agricultural Census when a male *Boston Globe* reporter called to ask what I thought about this "exciting new trend." He explained that the U.S. Department of Agriculture's National Agricultural Statistics Service (NASS) had put out a press release about the rise in the number of women farmers in the United States.

I said I wasn't surprised that New Hampshire had a lot of women farmers. I learned later that the reporter had told the commissioner of agriculture at the time, Steve Taylor, that he wanted to talk to one of these New Hampshire female farmers. Steve had referred him to me because in addition to being a partner in our family's dairy farm, I was an agricultural journalist and Steve figured I could deal with reporters.

Women had been full partners in family farm businesses for generations, I explained, and there were a smaller number who operated farms as sole proprietors. I told him my own grandmother had been a very important person in my family's farm business—she handled all the money. She also harvested and prepared fruit for sale, scrubbed and sanitized the milking machines, graded and packed eggs, dressed chickens, had an egg delivery route, and sold chickens and eggs to customers who came to the farm.

The 2002 Ag Census counted 2,115 women farm operators—or 39 percent of 5,414 total operators in New Hampshire, and their numbers continue to increase steadily. NASS defines "farm" as any farm enterprise reporting $1,000 or more in annual sales. New Hampshire had 3,363 farms in 2002. Operators are owners or hired managers who run the farm business. In the 2002 Ag Census, one out of four principal operators was a woman. These are sole proprietors or farm managers or are identified as the principal or senior partner or manager of a multi-operator farm.

Conducted at five-year intervals, the Ag Census collects data on a maximum of three operators per farm. New Hampshire has a higher percentage of multigenerational or multi-household farms than the national average, and multigenerational farms can have more than three operating partners—to include, for example, a husband and wife and one or more of their children (or nieces or nephews) and their spouses. Grandchildren may also join the family farm business. So women operators—and all operators—are likely undercounted to some degree.

From the 2002 to the 2012 Ag Census the number of

opposite page Elaine Haynes, Haynes Homestead, Colebrook

women farmers grew by 44 percent to 3,052. The growth of women farmers outpaced that of men, bringing women to 42 percent of the total 7,300 operators. Women principal operators increased even more—jumping 62 percent from 838 in 2002 to 1,258 in the 2012 census. In 2012 nearly one in three (31 percent) principal operators was a woman.

In close competition with other New England states that share our regional culture of women's involvement and leadership in farming and agriculture, New Hampshire was edged out of the top spot nationally for women principal farm operators. NASS has learned to strengthen outreach to American Indian communities, especially among the Navajo with their long tradition of women farmers, resulting in Arizona's also edging ahead. New Hampshire still far exceeds the 2012 national tally of 29 percent women operators and more than doubles the national 14 percent of principal farm operators.

New Hampshire and New England as a region defied the national 2012 Ag Census trends of slightly declining numbers of farms and farmers—both male and female. It is no coincidence that New Hampshire ranks among the top five states nationally in two agricultural categories: the percentage of farmers who are women and the percentage of farm sales classified as direct-to-consumer. These two percentages have grown concurrently over the past decade

or more. Women are among the leaders in innovative farm and local food marketing enterprises and initiatives—building on the roles and skills women have brought to farming for generations. The advent of the local food movement is bringing more consumers to pick-your-own and community-supported agriculture (CSA) farm programs, farmstands, and farmers' markets in pursuit of fresh, local, and distinctive foods. Women farmers are often answering the questions and making the sales.

Farming attracts entrepreneurial individuals who value the opportunity to create their own businesses doing work that they love. The local food movement has created new economic opportunities for farmers who enjoy producing food and other products for sale directly to customers. Women, with their involvement in school and community, and their understanding of their customers' preferences and values, often excel at communicating and building relationships with customers.

In this twenty-first-century world, farming allows an unusual degree of integration of work and family and life interests. The kinds of farming are diverse—but all involve multiple aspects of nurturing plants and animals, and working with nature and the land. Every woman charts her own course, whether she farms on her own, with a spouse or partner, as part of a multigenerational or multi-family

farm, or as a farmworker or manager. For some, farming is a more-than-full-time occupation. Others combine part-time farming with other jobs or enterprises, or with caring for children or grandchildren and other responsibilities. For others, farming is a retirement vocation. Still other agricultural professional women are involved in businesses, government, and educational or nonprofit institutions that provide support and services to farmers.

In these stories and photographs of New Hampshire women in agriculture, Helen Brody and Leslie Tuttle capture the essence of how each of their subjects crafts a rewarding and meaningful life through her work. These women are innovators and leaders in local and artisanal food production and in key industry support functions, such as marketing, education, and research. Their stories illustrate the qualities of character, hard work, and perseverance that farming demands.

Lorraine Stuart Merrill

COMMISSIONER | New Hampshire Department of Agriculture, Markets & Food

LORRAINE STUART MERRILL is a third-generation dairy farmer and partner with her husband, John, their son, Nathan, and his wife, Judy, in Stuart Farm, a 260-cow dairy farm in Stratham, New Hampshire. Prior to her appointment as New Hampshire commissioner of agriculture in 2007, Lorraine was also a freelance agricultural journalist and environmental technical writer.

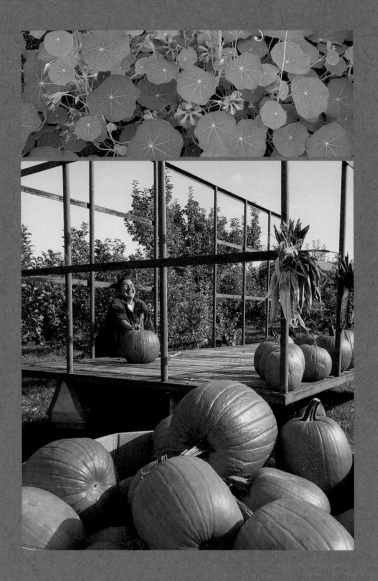

Introduction

REMEMBER WHEN the role of a woman on the farm was pretty much keeping the menfolk fed, keeping the farmstead clean, keeping the children scrubbed, and getting them off to school on time? Well, cast an eye on New England's local food movement today and you'll see that times are indeed a-changing. Increasingly, women are becoming more than loyal auxiliaries on the farm; they have become the prime innovators of New England's local food movement and are revitalizing the occupation called "farming."

While their husbands are using twenty-first-century farm tools and methods to increase crop productivity, the wives and partners are learning twenty-first-century marketing techniques to expand farm sales. Putting their imaginations to work, these indefatigable women are moving the conventional small New England farm into the realms of agritourism, modern technology (websites and social media), and consumer education. Community-supported agriculture (CSA) programs, often initiated and organized by women, have increased local food market share and involved the community in the farm's production.

opposite page Diane Souther, Apple Hill Farm, Concord

Kat Darling, Two Mountain Farm, Andover

And never to be forgotten are their traditional kitchen skills. Farm women hand out recipes with their CSA share baskets and display their eye-catching homemade pickles, relishes, and preserves on their farmstands while conversing with customers. And, oh, the aroma of those home-baked pies, cookies, and muffins deftly perched within reach of a customer's nose ensures impulse purchases.

Yet, despite all these new responsibilities, farm women have not neglected those time-honored tasks of feeding their partners and families well, keeping their homesteads clean, and getting the next generation of farmers off to school on time.

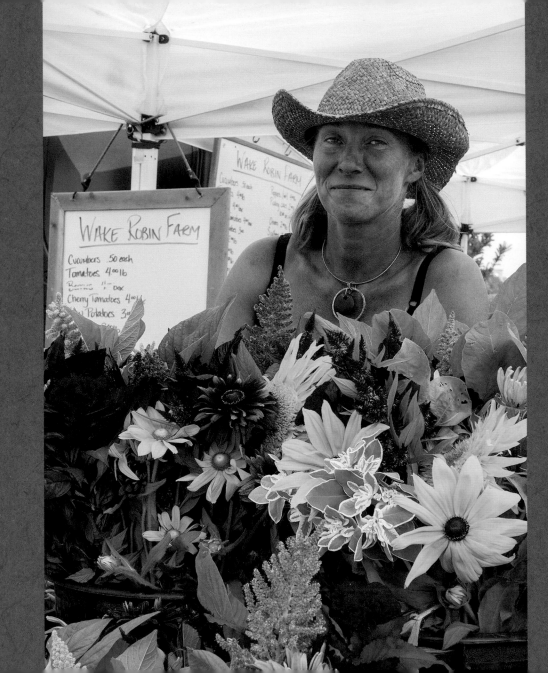

Women THE FACE OF THE FARM

FOR ALL THEIR WORLDLY WAYS, suburban, city, and local townsfolk have always had a fascination with farm life — the mysteries that attend working the good earth, tending to animals, the rhythms of the day, and the seasons. In recent years, slowly but inexorably, farm women have been bridging the chasm between these two cultures by unleashing their knowledge of holistic life and presenting healthier and more imaginative foods, stylishly and creatively displayed among their farm's offerings. Indeed, women are the educators of the product, vitality, and worth of the New England small farm. Farm women have become the face of New Hampshire's local farm sales, whether at the farm, in the city, or in a public arena.

Twenty-five or so years ago, as second homeowners began trekking to New Hampshire, looking for a respite from the pace of their urban streets, they found the Granite State a genuinely hospitable place to live. With the influx of these newcomers and with the overall spike in the preference for eating food grown close to home, summer farmstands and farmers' markets began to flourish. And lo and behold, the quality and flavor of foods grown on small New England farms began to take hold.

Today farmers' markets have expanded to year-round events, and the variety of foods in them continues to grow. To be sure, women cannot take all the credit for this burst of agricultural interest, but given their instincts for nurturing and their all-embracing approach to farm life and high-quality food, their impact is immeasurable.

opposite page Abby Wiggin, Wake Robin Farm, Stratham

Farm
Marketers

Center Stage

LONG BEFORE A FARMERS' MARKET OPENS, the women hustle to unload their farm trucks, set up their tents and displays, and compare crop notes with their farmstand neighbors. At the clang of a bell or the blast of a whistle, shoppers descend and farm chores are forgotten for a few hours.

Most treasured on the market season's opening day is sunshine. What better way to show off the dramatic splash of flowers and plants of the spring than a glorious day? As most summer produce is too young to pick, the early stars of the spring markets are annual flowers and seedlings. In fact, ornamental agriculture has become the largest financial agricultural segment in the state.

With the harvesting of May crops, the local and summer produce sales pick up and the role of the market vendor becomes not only selling but educating. There are always queries about lettuces and string beans, but it is the unique and rarely experienced heirloom fruits and vegetables and heritage meats that elicit the most questions. Signs and conversation are helpful, but nothing beats the food samplings — and it seems almost as if the customer is embarrassed or ashamed not to reach for a wallet after taking a taste. More often than not the buyer comes back for another purchase.

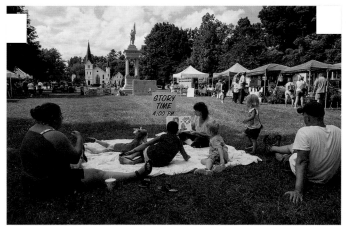

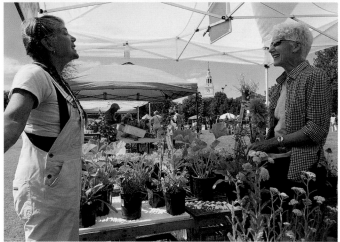

top Newport farmers' market
bottom Hanover farmers' market
opposite page Portsmouth farmers' market

Learning about scallops: *F/V Rimrack*, Rye

Hanover farmers' market

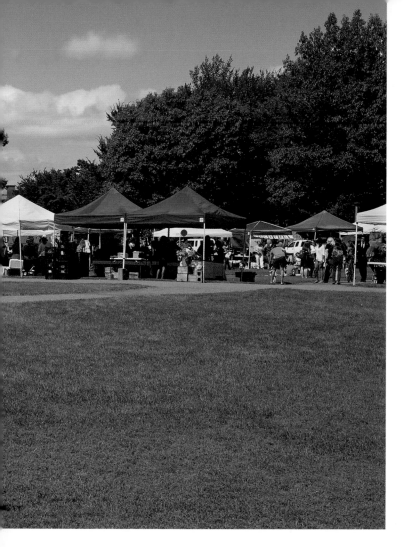

The women tending the stalls offer cooking suggestions, many from their own kitchens. These are also effective sales tools and are bandied about between buyer and farmer, while recipe cards—with the farm's logo and name embossed on them—are handed out as more permanent reminders of the source of customers' purchases.

The public seems to have an abiding interest in what life is like on the farm, and, recognizing the importance of education and loyalty to local food, women farmers encourage customers to make on-site visits to get a firsthand look at where food really does come from and also to make additional purchases.

Whether at the farm or at the market, farm women are sure to give special attention to the children, who must be weaned from thinking that produce comes from the ever-present supermarket cellophane bags. All farmers recognize how vital the education of the young is to the future of farming and the local food movement. Clearly, farmers' markets and farm women are where the connection between farm and consumer begins.

Suzanne LeBlanc at Danbury winter farmers' market

Suzanne LeBlanc

AUTUMN HARVEST FARM & QUILT STUDIO, GRAFTON

"To be successful as a farmer in New Hampshire, you must find a way to earn a living year-round," says Suzanne LeBlanc. "I know it is difficult, but I know it can happen."

Suzanne's quest for the right place to fulfill her vision started in 1999 when she and her husband, on a 1,200cc Harley motorcycle in good weather and a snowmobile when snow began to fall, began searching out affordable land. Eventually, the couple settled on a piece of overgrown property at the top of Hardy Hill in Grafton, New Hampshire. They harbored no delusions about the amount of work it would take to turn their rock-infested soil into productive farmland that could not only support them twelve months of the year but also provide a retirement savings.

Remarkably, by 2002 Suzanne, the marketing half of the couple, was able to enter the Enfield and Newport farmers' markets with a full array of freshly picked vegetables. The range of her offerings has grown from a few vegetables to include strawberries, home-baked breads, preserves, relishes, and pickles, all made from her own farm's pickings. The homemade goods, along with the most recent addition of frozen farm-raised lamb, supplement her winter vegetable offerings and represent Suzanne's ongoing effort to in-

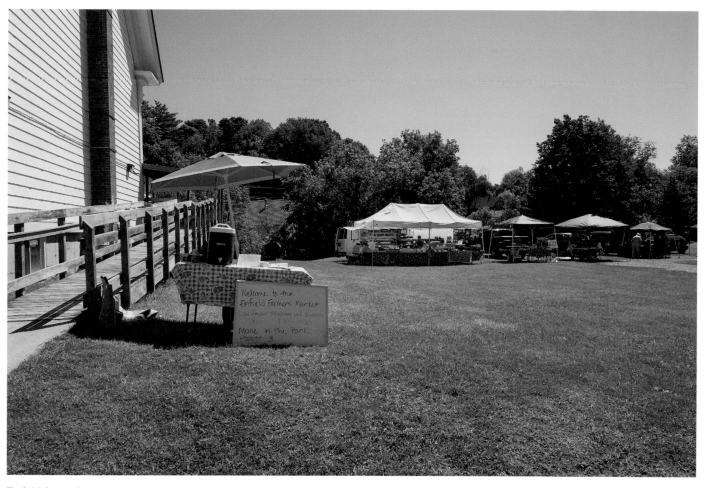

Enfield farmers' market

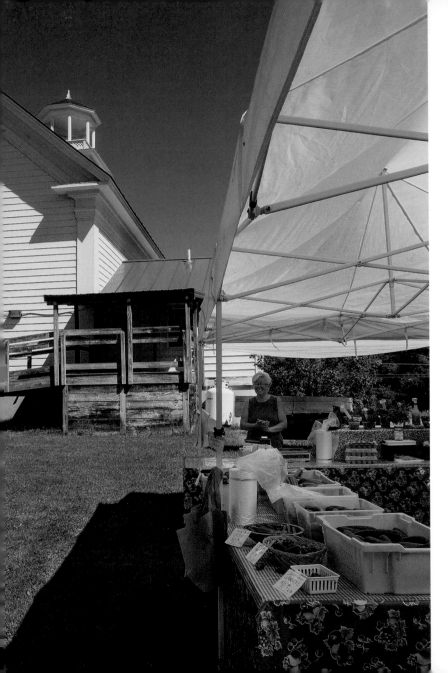

Autumn Harvest Farm produce

crease the winter market sales so that Autumn Harvest will become the year-round sustainable farm she envisions.

For those who have never set up a stand at a farmers' market, it is difficult to grasp the energy and backbreaking work that it demands. At each summer market Suzanne must pack, unpack, and repack her white van with enough product to fill up two 10-foot × 20-foot tents. Her bountiful stand, along with her knowledge and personable nature, have made Autumn Harvest one-stop farm shopping for many market customers.

Enfield farmers' market

Louisa Spencer

POVERTY LANE ORCHARDS & FARNUM HILL

CIDERS, LEBANON

"Fermented" or "aged" ciders, more commonly known in the United States as "hard" ciders, are made from apple juice, much as wines are made from grapes. In the United States during Prohibition, the word "cider" lost its alcoholic reference, becoming the common term for fresh unprocessed apple juice. In the late 1990s, Farnum Hill Ciders became an early leader in bringing dry orchard-made ciders to New England palates.

With the market price of premium McIntosh apples sliding in the late 1970s, and wanting their farm to remain an apple enterprise, Louisa Spencer and husband Stephen Wood began to test and plant little-known apple varieties for specialty markets. By the 1980s, they had also put in acres of inedible bitter, tannic cider varieties, common in England and France and grown exclusively to make superior dry fermented ciders. Already an expert apple grower, Steve learned wine-making methods and began years of experimentation that eventually produced Farnum Hill Ciders. It became Louisa's responsibility to introduce the ciders to restaurant and retail establishments.

She faced enormous marketing challenges. Deciding

Louisa Spencer

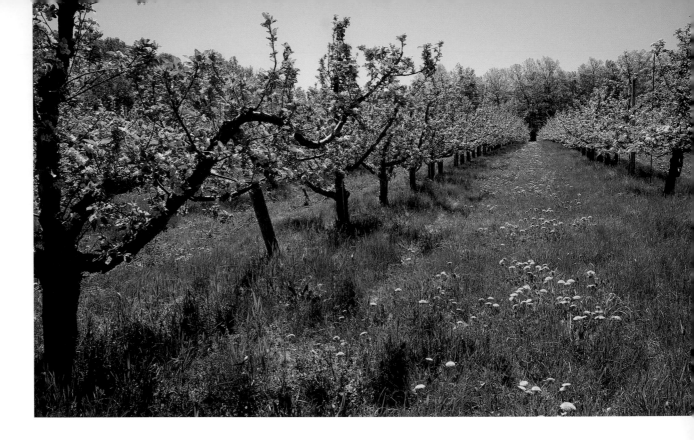

Farnum Hill orchard in spring
bloom and heavy with fruit

on descriptive wording and label design posed the first big problems. Then giving an explanation of what to expect before people tried the samples was important. Louisa says, "I had to assume that Americans, seeing the word 'cider,' thought of a sweet seasonal brown juice and autumn donuts, and warned them not to expect apple juice flavor

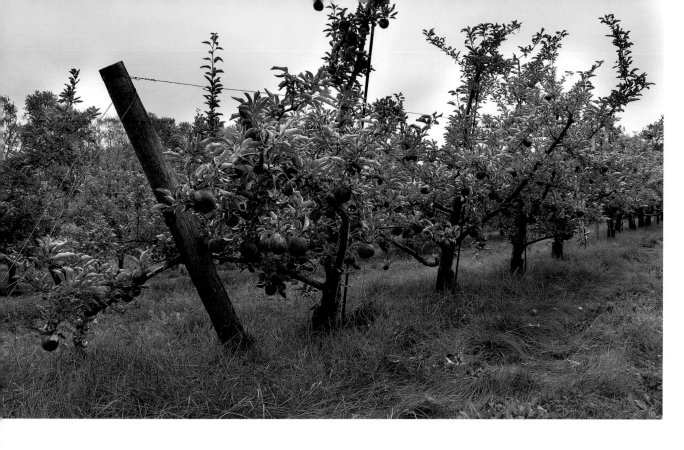

any more than they expect grape juice flavor from a wine bottle!" To reduce the shock, it was critical, she discovered, that she speak of the dry, fine-cider flavor before they tried her samples and was always relieved to hear British and European accents because they signaled tasters who needed no warning beyond the words "dry cider."

Although she began her quest for a market in New Hampshire, often at farmers' markets, progress was slow locally until the New Hampshire Liquor & Wine Outlet stores began accepting in-state products in 1990. The earliest breakthrough occurred in New York City, where Farnum Hill Ciders could reach a large wine and media

Ready for picking

would be ready for her meetings the next morning. "Wine and restaurant people are not usually early birds, so I never had appointments before 10:30 a.m.," Louisa says.

The earliest acceptance of Farnum Hill Ciders came from a few of the most famous restaurants in the city, where she could point out to the staff that they had the power to set trends with a new product, and they became enthused. Since retail stores needed "point-of-sale" shelf signs, she learned computer layout programs at a local community college, so by the time the New Hampshire state liquor system expressed interest, she was prepared with advertising materials and store tastings.

Farnum Hill's cider is now available in most north-eastern states and in various urban markets around the United States. Fermented ciders' share of the drinks market has grown more than 500 percent since 2009. Finally, the growth of artisanal ciders has rewarded Farnum Hill's big plantings of inedible cider varieties back in the 1980s and 1990s. These specialized apple juices now bring excellent prices, and other commercial orchards are beginning to plant true cider fruit. "One of our satisfactions is that this whole trend will help apple growers," Louisa says. "We took this long path to stay in the apple business in spite of imported fruit."

market. Months of "cold calls" to wine buyers identified a few willing to taste. Shipping samples to them and letting them "pop a cork on their own" proved less successful than pouring in person. As her children were still young, Louisa found the best plan was to jump in the car about 8:00 p.m. after they were in bed and drive to New York so that she

Kate Donald

STOUT OAK FARM, BRENTWOOD

Historically, U.S. farming has been a family tradition. Fathers hand down their land to their sons and then on to their sons or daughters, with multigenerational farms dotting New Hampshire's landscape.

But today's farmers also come to their careers in a variety of other ways and for a variety of reasons: young couples may be looking for a less hectic life for their families, one that allows them to escape urban sprawl or teach their children self-sufficiency; second-career professionals may yearn to get their hands in the soil, often because that is how their grandparents once worked the land and lived off what they had produced; and young farmers may have worked their way through the network of an agricultural college, leased land, and joined regional farm support groups to learn their trade and to help move forward what today we call "the local food movement."

Kate Donald, a rare New Hampshire native, falls into this last category. She is a Georgetown University graduate with a certificate in ecological horticulture from the University of California, Santa Cruz. Her experience with West Coast farming gave her a basic training in organic agriculture, and working on urban projects gave her a taste of city farming.

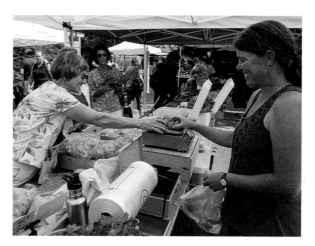

Kate Donald at the Exeter farmers' market

After moving back to New Hampshire, she leased land in Epping to begin a community-supported agricultural (CSA) program and to sell produce at the Exeter famers' market. She also contributed to the founding of Seacoast Eat Local and became a mentor to Northeast Organic Farming Association–New Hampshire (NOFA-NH) Beginning Farmers. In sum, she had established her credentials as a conscientious and committed farmer.

In 2012 a nearly 60-acre easement of productive farmland, formerly Creamery Brook Farm, was acquired by the Southeast Land Trust, the Town of Brentwood, and the U.S. Department of Agriculture's Natural Resources Conservation Service (NRCS), but what the group needed was

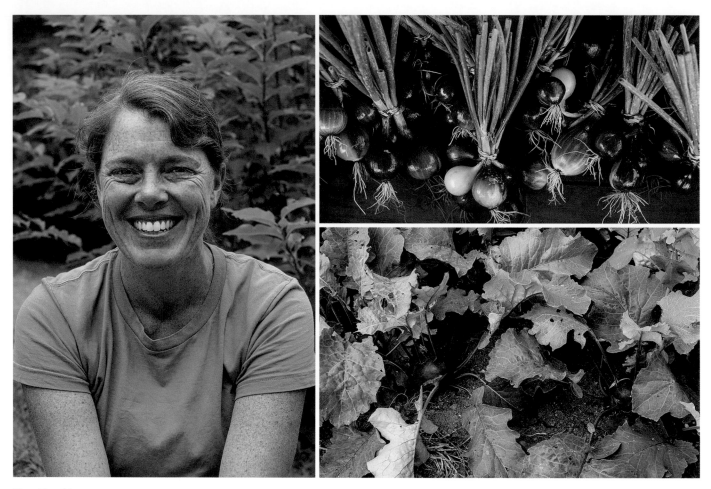

Kate Donald

a bona fide farmer to purchase and develop the acreage as farmland. Up stepped farmer Kate and her husband, Jeff, who had been a local agriculture supporter as well. They were the natural choices.

The land currently owned by Stout Oak Farm was managed as a dairy farm by the Robinson-Lyford families from the early 1880s until the 1960s. Organic certification regulations require that no prohibited materials be used on the land for three or more years before certification, but as the land had not been actively farmed for several decades, it was only a matter of filling out the paperwork to be certified. Unlike many farmers who are irritated by having to tackle forms, Kate does not find dealing with such details a burden. Quite the contrary, in fact. "I feel more comfortable," she said, "knowing my vegetables have the certified organic 'stamp of approval' when I am speaking with customers."

Each year Kate seems to overcome the labor problems that beleaguer so many farms. "We cannot provide housing for our workers," she said, "but we are fortunate because each year brings in a new crop of good workers." What Kate did not mention was the respect she has for the workers, many of whom also have off-season restaurant jobs because the hours are complementary to those the farm requires, and, as she says, "we have a strong culture of hardworking women on the farm." There are those whose applications speak of their interest in permaculture or the environment, "but what I need—and what they become—are production-oriented women willing to do different tasks around the farm. And the work-share program we offer, it's all women; they love to weed!"

Since she began farming at Willow Pond Community Farm in Brentwood ten years ago, Kate attends only the Exeter farmers' market. "To go to more than one market would duplicate what other farms are selling," says Kate, "and we would have to split our harvest into too many different locations."

Instead, she plans to focus on building up her retail farm store and her CSA. A third venture she hopes will mature is the Three River Farmers Alliance, a burgeoning distribution system she helped develop with the owners of Meadows Mirth Farm in Stratham and Heron Pond Farm in South Hampton. "We work well together," she said, "and that's serendipitous because rather than having too much of one thing, we seem to complement each other with a variety. If one is short one week, the other takes up the slack."

Finally, Kate has what seems to be a singular talent among farmers for understanding the value of marketing. Monday, when the store is closed, she's at her desk and computer. "Without that marketing piece," she says, "the farm would fall apart; it must be done."

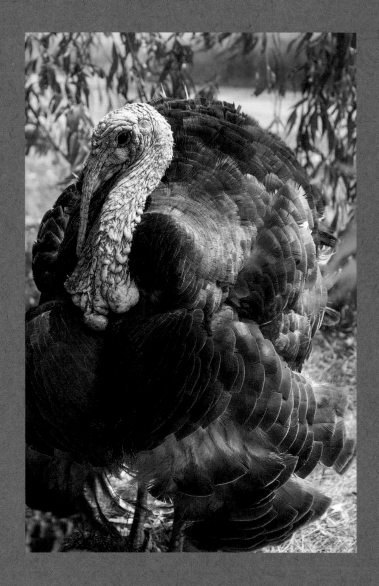

Promoting
Heritage Breeds
and Heirloom
Produce

UNTIL THE LATE NINETEENTH CENTURY, meat was locally raised and primarily grass-fed. With the arrival of cross-country refrigerated transportation, the livestock industry standardized animal breeds, weight, and feed. Today, mega-farmers, to increase weight quickly, replace grass with grain in the animals' diet before slaughter.

By eschewing the grain finale and returning to the largest percentage of the animals' diet being grass, New Hampshire farmers are providing a meat that is leaner and free of added hormones, artificial food additives, and unnecessary antibiotics. Many believe grass-fed beef yields a healthier alternative to factory-raised beef. Yes, there are those who find the fattier grain-fed beef to be tastier, and no doubt the battle will not soon be resolved, but women, with a sustainable approach to farming, are at the forefront of the movement to feed farm animals with crops grown on one's own farm.

There is a growing interest in raising heritage breed animals. Scottish Highlander and Galloway cattle, Berkshire and Tamworth pigs, Icelandic and Tunis sheep, and buffalo are now finding a place on the shelves of local marketplaces. The genetic traits of these heritage animals hark back more than a hundred years, to ancestors most of whom were accustomed to rocky terrains and harsh winters—in other words, New Hampshire.

Not to be left behind by meats, organically raised heritage poultry, such as Pilgrim geese, Bourbon Red turkeys, and Pekin and Duclair ducks, are being raised in increasing numbers on local farms.

New Hampshire vegetable and fruit growers, too, are beginning to rebel against standardization. Rather than buying one variety for their plantings, they are searching out heirloom, organic, and local seed producers who offer many different seed possibilities. At local farmers' markets

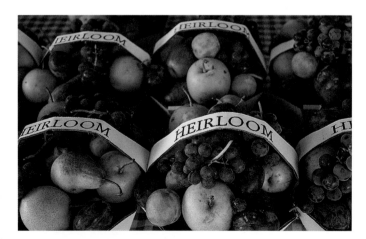

opposite page Bourbon Red turkey, Patridge Farm, North Haverhill

Alyson's Orchard heirloom produce, Walpole

and at farmstands, women proudly offer samples and educate customers about the surface spots, unusual colors, and sometimes bizarre shapes that attend such heirlooms as Calville Blanc d'Hiver or Esopus Spitzenburg apples, Brandywine or Green Zebra tomatoes, and Purple Viking potatoes.

Without a doubt, heritage meats and heirloom vegetables, thought by many to be more flavorful and vitamin-packed than other varieties, may require people to take a deep breath before digging into their wallets. Even high-end restaurants, usually on the front line of new specialty product introduction, have been reluctant to offer these ancient varieties because of their price and the extra bookkeeping that going outside their normal distribution network requires. But as one might expect, the best chefs, seeing the promotional (and flavor) advantage of introducing locally farm-raised heritage meats and heirloom fruits and vegetables on their menus, are reaping the benefits of customers' positive responses. New Hampshire's Farm to Restaurant Connection program has been instrumental in making this critical and emotional link between farms and restaurants.

Keira Farmer

To help pay for college, Brian Farmer made extra money flipping buffalo burgers for his cousin at fair concession stands. Needing more help, Brian hired a very attractive college coed named Keira, and a year later they were married. After graduating from college, the two followed their respective career paths, Brian in engineering and Keira in marketing. Forever etched in their taste buds, however, was the flavor of those buffalo burgers.

In 1997 Brian's cousin offered to sell the couple five buffalo, and, unable to resist the temptation, they began raising these gargantuan beasts on family property in Hillsboro. While Brian continued to work full time, Keira reduced her work hours to care for the animals—meaning that she essentially gave them food and water. Buffalo are pretty much maintenance-free, no housing required, and they eat field grass and hay.

By 2002 the couple was able to purchase 16 acres of an 1800s dairy farm, which included a small farmhouse in Warner. It was then that Keira talked Brian into becoming a farmer full time. What to name a farm is always a big decision, but since the couple had been born and raised in New Hampshire and had the last name "Farmer," Yankee Farmer's Market seemed a good choice: it would be a curiosity and give Keira a twist for marketing their new farm business.

Menu at Sandwich fair

opposite page Keira Farmer, Yankee Farmer's Market chuck wagon at Sandwich fair

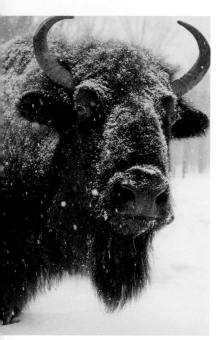
Buffalo

Today the farm averages fifty head of buffalo pastured in Warner and Hillsboro. Brian manages the herds and farmland; Keira oversees wholesale accounts and the farm-stand retail sales. She is also the marketer, bookkeeper, and webmaster; sets schedules with the meat processing and packaging plants; and arranges the farm's traveling concession schedules.

The uniqueness and size of the buffalo roaming the farm have made Yankee Farmer's Market a regular destination for families. Recently, to build on their farm business, the couple began raising chickens, pigs, and cows and selling the products of neighboring farms. "Ten years ago, I would have said 'no way' about beef," says Keira, "but grass-fed beef, like buffalo, is low-fat meat, and by bringing greater public awareness to our beliefs in raising humanely treated and well cared for animals, we hope people's fear of eating what they see will be eased."

Wrapped round hay bales at Yankee Farmer's Market

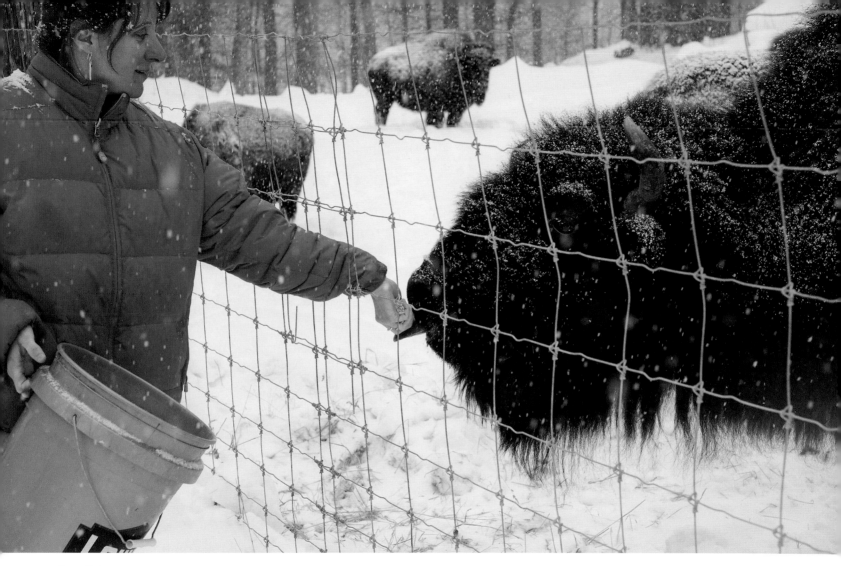

A gentle tongue

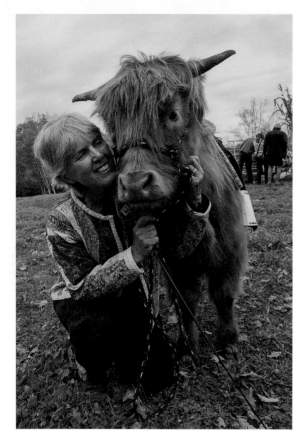

Carole Soule with Scottish
Highlander cow

Carole Soule

MILES SMITH FARM, LOUDON

If there is such a thing as an "oops" farm, Carole Soule and her co-owner husband, Bruce Dawson, might lay claim to such a phenomenon. During dinner one day in 2002, as the couple watched their two Scottish Highlander cows clear brush on their front field, a discussion between them ensued about the high quality of their animals' meat, and a beef farming business was born. "I wasn't even a beef eater," says Carole.

She had owned and lived in the property's farmhouse on Whitehouse Road since the 1970s, when it was used as a school for delinquent children. But by the late 1990s, Carole was on to new challenges, joining the high-tech world as a sales and marketing information technology expert with a company later to be bought out by Hewlett-Packard. It was a most fortuitous move because it was at HP that she met Bruce.

By then the farmhouse was showing the ravages of age, and the land was becoming overrun with brush. But one of the advantages of working for an IT giant was solid wages, so Carole and Bruce began accumulating the funds to bring the property back to life. For sixteen years they fixed

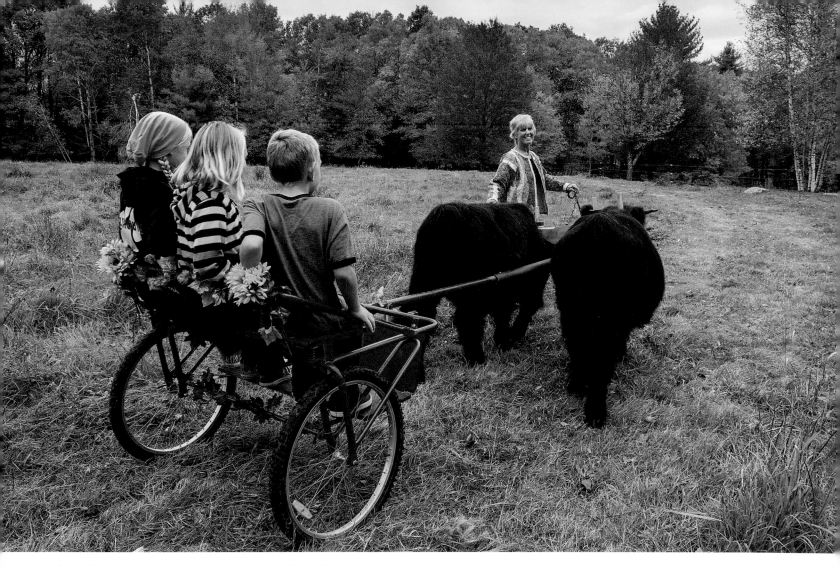

Carole Soule guiding children's cart at Miles Smith Farm Day

Farmyard

up the house, and it was during this time that they discovered the need for animals to help keep the brush down. Predators were no match for the large Scottish Highlanders, and the cows' heavy shaggy coats insulated them from New Hampshire's harsh winters. Moreover, Scottish Highlanders are docile animals with easy birthing, so the couple began breeding them. Rather than use machinery on their rocky and stump-filled soil, they allowed the animals to clear the pastureland while tilling the soil with their hooves and adding fertilizer along the way.

Interest in eating local food had been gaining a foothold at farmstands and farmers' markets during the 1990s. Along with this trend was a growing interest in lean, grassfed meat that was high in protein. Carole, with her HP sales support and marketing background, saw the business potential of meat sales, so the couple began breeding Scottish Highlanders, sometimes, she says, called "the Queen's cows," and began selling their beef in 2005.

Farm Day information session

As the farm's meat business grew, the couple found that 36 acres were no longer sufficient to feed the animals, so they began leasing land around the state. Carole likens herself to a "soccer mom" as she and Bruce load the cattle into what they call their "cattle taxi" and move the animals to greener pastures for cutting brush and fertilizing. Thus far, the animals have "recovered" more than 300 acres of over-grown fields and orchards—all land that normally would have been mechanically mowed.

As time went on, they discovered that some customers preferred meat with the same flavor as that of their Highlanders but with a little more fat, so they began raising Angus cattle as well. Like the Highlanders, they are 100 percent grass-fed, and, for those who like their meat even fattier still, the farm began a grass-fed and grain-finished

left Farm helpers with cattle at Farm Day *middle* Fiddler on hayride at Farm Day *right* Scottish bagpiper at Farm Day

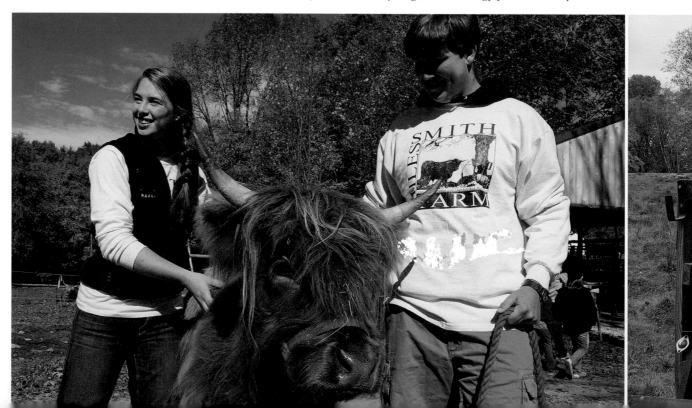

regimen. To complete their farmyard, they added a few pigs and chickens.

And what about the end-of-life question? Carole answers, "We only deal with processing facilities that follow the guidelines created by Temple Grandin, the well-known developer of humane livestock facilities, so we know our animals are treated with respect right until the very end."

Today Miles Smith Farm supplies hospitals, markets, and schools with meat. When asked if they have competitors, Carole responds with a measure of heat. "There are no competitors in local farming. It makes me furious when a store refuses to give us the name of their local meat supplier because they are 'your competitor.' We want to work with and support all farmers; as 'the tide raises all boats,' so it is with the success of our local farms."

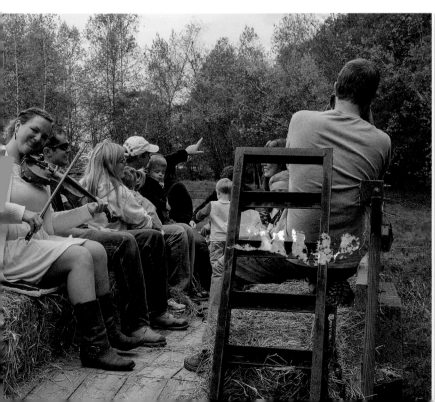

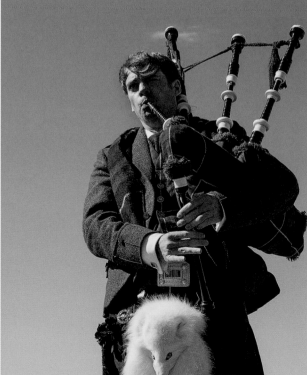

Encouraging Year-Round Buying of Local Food

LEADING UP TO THE HOLIDAYS, recently picked pumpkins, squash, root vegetables, winter greens, and apples give early winter markets an initial sales boost. But as New England states move into the post-holiday lull in January through March, the attire and hustle of the winter indoor farmers' markets must compensate for the dull days outside. As if in an effort to replace the colorful vegetables of summer, the women are dressed in brightly hued home-sewn patchwork skirts, and hand-knit warm stockings and hats, while skeins of homespun yarn draw attention to their winter hobbies. Taking advantage of returning summer purchasers looking for local meat, an increasing number of produce farmers are raising a few animals for frozen meat sales, which have become the anchor for winter farmers' markets. Recently, with the growth of hoop houses, winter markets have been able to expand their offerings into a large variety of greens.

Beyond the winter markets, regional efforts such as the Neighboring Food Co-op Association have been focusing on establishing a year-round local food supply. The Association, representing food co-ops in five New England states, is studying processing and freezing locally grown foods with regional co-packers. North Country Farmers

Donna Abair of Hazzard Acres Farm, Springfield

Co-op provides delivery service to restaurants, hotels, and schools of New Hampshire's North Country. Local Foods Plymouth, established in 2006, is a successful online service connecting local farmers and buyers. The University of New Hampshire Sustainability Institute is working to establish an overall food strategy by establishing a network of groups that contribute to the New Hampshire food system.

Most important, farmers themselves, often with private funding encouragement, are researching cooperatives for multiple farm sales to or from one location. Neighborhood businesses prefer these local groupings to lower their distribution costs. The bookkeeping time required to buy from several farms individually discourages permanent market or restaurant sales relationships.

opposite page Outside Danbury winter farmers' market; Mary Fanelli (top) at Blazing Star Grange

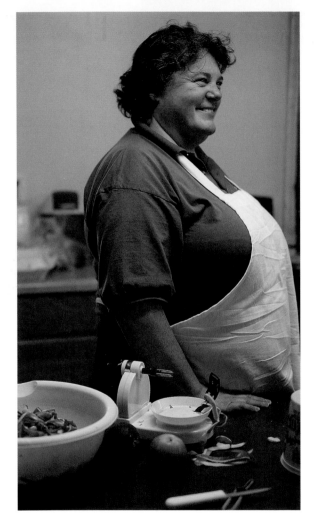

Donna Sprague's kitchen

Donna Sprague

HUNTOON FARM, DANBURY

After her father, Willard, died in 1988, Donna made a pact with husband Phil: "Losing the farm on my watch is not an option. We cannot take risks." So the couple made a business plan from which they would not stray and that would allow them to work full time on the farm within five years. "I laugh," she says today. "For those looking for inspiration, our path has been crooked and took some circular cow paths along the way. Our five-year plan took fifteen years."

Huntoon Farm, dating back to 1856, was purchased by Donna's great-grandfather Harvey Huntoon. From age eight, she had wanted to work beside her father on the family's 362-acre dairy farm. After graduating from the University of New Hampshire in dairy management, she returned home to find that the milk companies had decided the farm didn't have enough cows for regular pickups. Feeling that the cost of expanding was too great, Willard switched to raising meat, and Donna, who had always enjoyed cooking, began pursuing food preparation opportunities. First came a New London pastry shop, followed by work in the local school lunch program, which gave her summers off to build the farm business and move forward with her plan.

Her commercial kitchen today was once the farm's woodshed, and, with affordable yearly construction changes and equipment upgrades, she became licensed for baking and food production. While she makes the prepared foods using their own beef, chicken, and eggs, Phil makes the bread and pies, handles the animals and chores, and takes care of the vehicles. "I do miss the farm chores," she says, "all except I don't kill chickens. I don't kill things." She handles the farm business, website, and social media—"paints the signs"—and is working to standardize the recipes for her growing food business. What took the most time and energy to reach her goal of working on the farm full time was finding sales locations.

During the summer, the Wilmot and Canaan summer farmers' markets bring in dollars from meats, baked goods, and prepared foods. During the winter, it was tough for the farm to navigate financially. Danbury's Blazing Star Grange on North Street had always been the center of activities while Donna was growing up, so as part of her effort to introduce new projects to support the Grange, in 2007 she started one of the state's first winter farmers' markets. "Today," she says, "the market continues to be small, but lucrative, because we have been careful not to

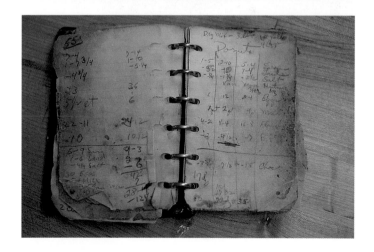

top Farmhouse store entrance *bottom* Fifty-year-old recipe book at the farm

Donna Sprague with turkey chick

have much overlap of farm products and we have awesome clientele."

The next big financial breakthrough for the Spragues came with the development of Local Foods Plymouth (LFP). A nonprofit organization founded by the Plymouth Area Renewable Energy Initiative and D Acres Organic Farm & Educational Homestead in Dorchester, LFP is a regional hub of farmers connected to consumers by the Internet. "Since our isolated farm location requires that we take our food to market, this system works very well for us," says Donna. All food is paid for in advance, and the couple can offer any amount of whatever they have available for sale. There are no minimum or maximum quantities. The product drop-off point is the Plymouth farmers' market in the summer and the UPS store in the winter. At first, only small amounts were ordered. "We delivered even the smallest orders, which meant we lost money on time and gas but built a loyalty that made our business profitable."

Soon after connecting with LFP, the Spragues began delivering their farm products to the Danbury Country Store. Donna boasts, "At the end of 2013, for the first time we had money in the bank and were able to begin full-time work on the farm." With immense pride she adds, "Just as we had planned fifteen years ago."

Donna Abair

HAZZARD ACRES FARM, SPRINGFIELD

"I like living in the woods," says Donna Abair. "No one bothers me and, besides, my son has given me a calling here." Son Raymond, when he was age seven, found the large size of the horses that had been Donna's childhood interest intimidating. Pigs became his animals of choice to show at the Merrimack County 4-H competitions, and he did well; he has a myriad of blue ribbons posted above his farmhouse desk.

As he approached college age, Raymond found that being a full-time farmer had lost its appeal, and, wanting to be a firefighter instead, he moved 235 miles away to study public safety at the University of New Haven.

But then, what was to be done with thirty sows and a thriving piglet business while he was at school? Donna had always been in the wings to help when she was available, but she needed to keep her off-the-farm job driving a school bus to help pay tuition bills. Her son's pork business, however, was doing well, so she decided that if she cut

left American Spotted sow with piglets at Hazzard Acres Farm *right* Donna Abair

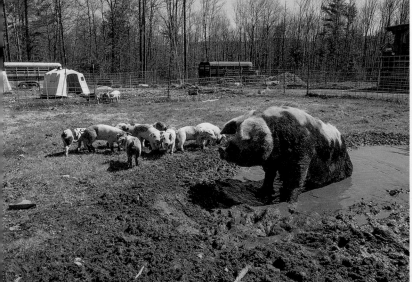

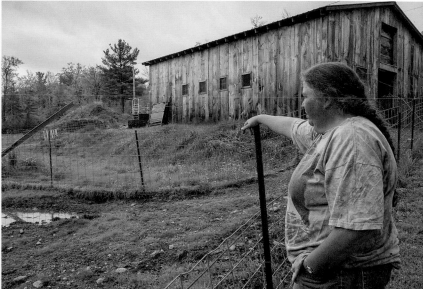

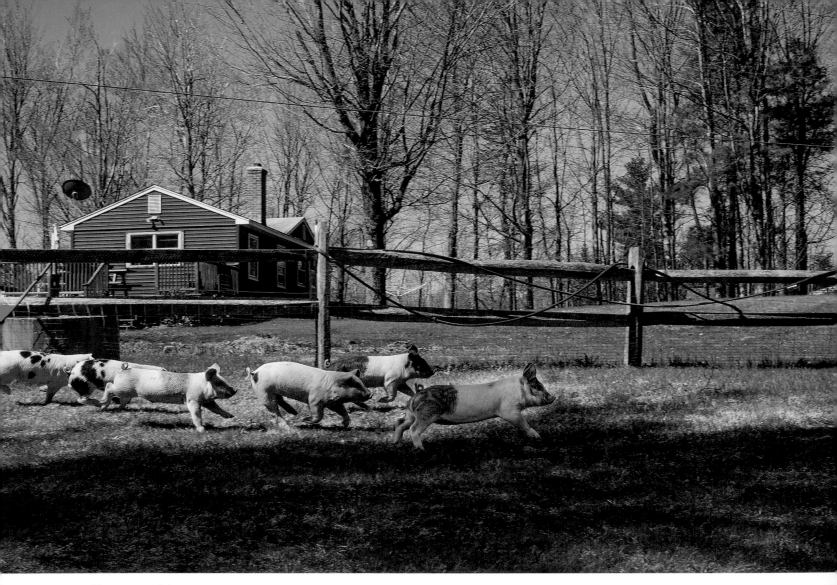

The running of the pigs

Donna Abair's garage

back on the number of sows, she could continue to work, manage the farm, and sell frozen pork year-round from the farm and at farmers' markets.

Raymond had been raising three different breeds: the Berkshire (black), which is popular in New Hampshire; the Landrace (white); and the American Spotted. "After a test taste, only one person could tell which breed was best, so why not choose the easiest and the most fun to raise?" she said. So American Spotted it was.

Old Spots, originally from Gloucestershire, England, were nicknamed the "orchard pig," as they were most often found in orchards scooping up windfall apples. Their clearly defined black spots give them their name, and the spots' size and clarity are major factors in competitions at the Deerfield Fair, one of the largest agricultural fairs in the state, where Donna shows each year.

Besides "being fun to raise," American Spotted pigs are good producers. Half of Donna's business is the sale of pig-

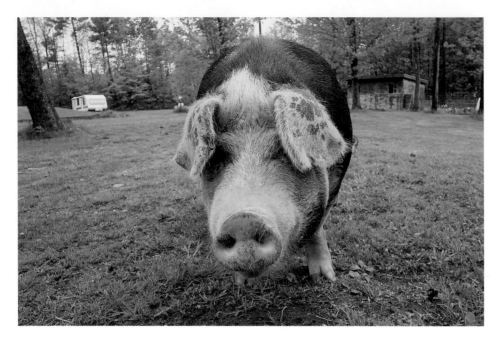

700-pound mama sow

lets, so she regularly issues a caution (to the pigs) that, to remain on the farm, they must produce ten salable piglets twice a year. And she is a tough taskmaster. "To stay here they gotta behave."

In addition to raising piglets, Donna keeps four replacement gilts (pigs that have never been pregnant), five sows for breeding, and two boars. The gilts Donna shows at the Deerfield Fair before breeding them and keeping them on the farm.

A clear advantage of the American Spotteds ("Spots" for short) is that, although they must remain in the barn at night for protection from coyotes and coydogs, outside they move from field to field, clearing land as they go and leaving the family with exquisite lawns. "Put corn kernels around the stump and they will pull out most of the stump." Donna screens the soil that the pigs have fertilized and sells it for lawn plant food.

And where does Raymond fit into this picture? He continues to help his mother when he is home, and Donna continues to hope that one day he will return to farming.

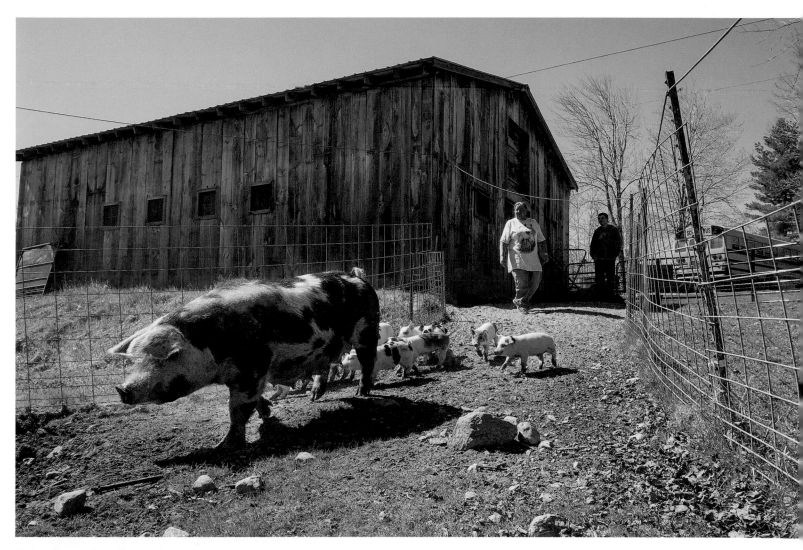

Donna Abair and son, Raymond

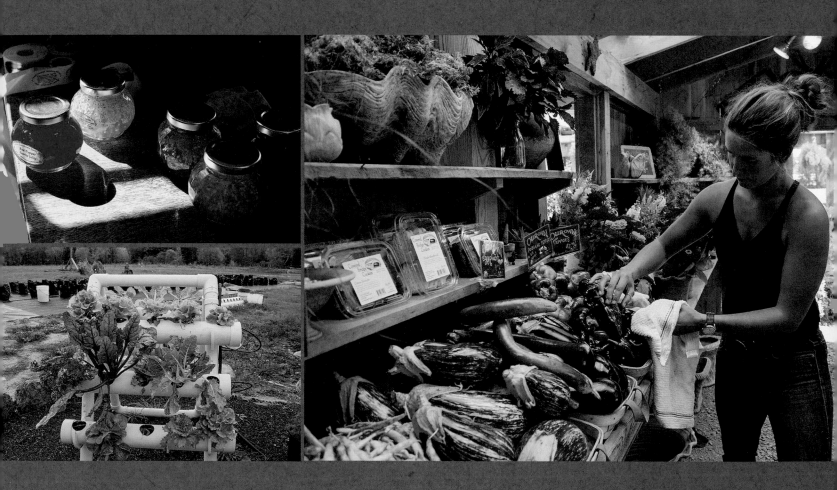

Women CATALYSTS
FOR FARM GROWTH

ASK WHICH MEMBER of the farm family thinks outside the proverbial box when it comes to making the enterprise grow, and the answer inevitably will be a *woman*.

As for clearing the land of New Hampshire's ubiquitous boulders or plowing long straight rows in the fields, as of old, it is most often the men who continue to take on those burdens. But today's off-the-field marketing intricacies of website design, social media, farm events, and publicity seem not to be as intimidating an activity for farm women as they are for their partners working the land. There's no denying women have a genuine knack for speaking at fairs, town meetings, social occasions, and promotional events.

As keepers of the books, women are ever mindful of the minutiae of income and outgo. At the farmstand, in tracking the sales of baked goods, preserves, pickles, rel-ishes, pestos, and whatever else their imagination conjures, they watch and evaluate the purchases of their custom-ers—what products visitors enjoy when they picnic in the orchard or in the field and what goes into the car to take home. And they are mindful that labeled packages and jars establish farm recognition, encourage return visits, and are future motivators for a mail order business.

Nor can we forget the unappreciated job of dealing with the vagaries of employees and seasonal help—another vital element in the women's bag of responsibilities, responsibil-ities that most assuredly fall outside the box of "farming."

opposite page, left top Garlic jellies, Two Sisters Garlic, Canterbury *left bottom* Hydroponic growers, Sticks and Stones Farm, Center Barnstead
right Sarah Sprague Houde polishing peppers, Edgewater Farm, Plainfield

Creating
Imaginative
Visitor
Attractions

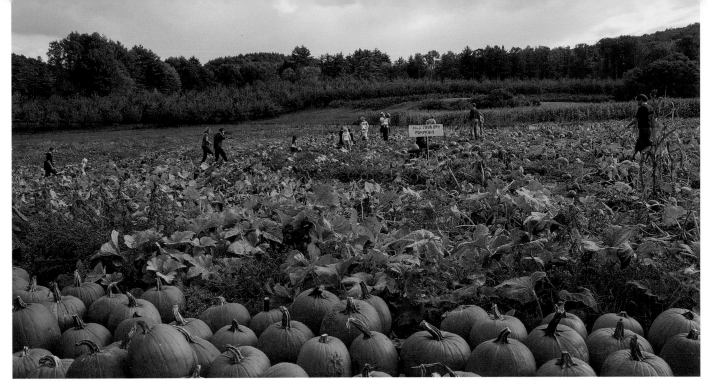

Pumpkin-picking patch at Riverview Farm, Plainfield

SEASONAL ACTIVITIES, primarily for children, encourage multiple return visits to the farm. Corn mazes, pumpkin cutting, and apple tastings in the fall; seed planting in the spring; summer camps, hayrides, children's games, farm dinners, and educational programs—all take place throughout the growing season. Women have become adept at designing websites, planning newsletters, and using social media to publicize activities and special events.

opposite page Family activities at Bean & Greens Farm, Gilford

Nancy Franklin

RIVERVIEW FARM, PLAINFIELD

While many of today's farms have foiled nature by extending the seasons, Plainfield's Riverview Farm remains faithful to the old ways; it is a fall pick-your-own farm for berries, apples, pumpkins, and flowers, and that's it. For the rest of the year, Nancy Franklin, co-owner with her husband, Paul, turns to other affairs.

In the autumn, the smell of fresh donuts wafting from their home kitchen at six o'clock in the morning signifies that the farm is open for the season. Despite her family's pleas that she buy a commercial fryer with its own foolproof batter recipe, Nancy continues with her tried-and-true method by calling on the recipe perfected by her grandmother and handed down to her by her aunt.

"The commercial fryer donuts just aren't the same," she says. Oh, she does admit to tweaking the recipe a bit to make the dough easier to handle, but lest she stray too far from the family's two-fry-pan method, five donuts in each pan, her grandmother's donut storage tin sits next to the stove as a reminder. "The donuts last until about two o'clock—unless the Dartmouth boys show up," she says.

Nancy Franklin with corn maze scarecrow likeness

Hayrides at Riverview Farm

While the spawn of Nancy's two fry pans are indeed special, inasmuch as a farm cannot survive on donuts alone this lovely 44-acre orchard farm overlooking the Connecticut River yields much more of interest to the visitor.

In a country barn, Nancy manages the farm's store, lends a hand lifting pumpkins onto the counter for the children, and offers them a cup of fresh apple cider. Not surprisingly, their parents then buy a quart. All during the season, the family, led by Nancy, bunches and hangs flowers from the barn rafters to dry and be purchased. There is also a large pick-your-own fall flower patch for those who want to gather their own bouquets to take home. Old-fashioned canned goods, like homemade apple butter, cooked on the family's woodstove during the winter, are available for sale and are often sampled.

As visitors arrive and park their cars in the fields, the farm's horse and wagon transports them to the heart of the farm—the orchards high in the Upper Valley hills. "The wagon is an attraction," Nancy says, "but it's also a way of managing people and keeping cars out of the orchards." She hires a local farmer who knows the history of the farm and the Upper Valley to drive the wagon into the orchard that sits up a steep hill on different-level terraces, allowing the pickers a view of the canopy of dwarf apple trees down the hills.

During the season, Nancy's work is not devoted solely to events on the farm. There are the Lebanon and Norwich farmers' markets to oversee, the website, and publicity. And with twelve varieties of apples to choose from, a priority is to increase the farm's wholesale apple accounts.

Each year, Nancy and Paul commission artist Gary Hamel to design a themed corn maze, which has set the farm apart as a must-visit in the Upper Valley. In the early days, the Franklins designed and mapped out the mazes themselves. Their first effort was an ecological history of the Upper Valley. After doing several other historically ori-

ented mazes, Nancy met Gary and handed the project over "to his clever mind." The mazes all have tales to tell. The "Von Cotswalds" maze parodied the Cornish Art Colony period. Visitors searched for Vincent Van Goat's missing left ear, which turned out to be a painting of a missing ear of corn. All the characters in the maze were animals, like Mary Catsat, Grant Woodchuck, Henri Ratisse, and Paul Goatguin.

Another year their daughter's wedding was the inspiration for the story "Sleeping Snowrella." The princess was awakened by the prince's kiss, but to be married she had to find her way through the castle maze to the altar. Everyone who was in the actual wedding was a character in the maze.

In 2013 the theme was healthy eating, active living. The caring daughter of a gypsy helps the depressed, overweight boy king of Epicuria by getting him to exercise his way to a healthier and happy life.

To finish their season, the maze becomes haunted and, says Nancy, it is a "low-tech, fun way to end our year." Employees, friends, and family dress up in their favorite costumes; Paul dons a hockey mask, revs up his chain saw, and for two nights the screams pierce the night.

Riverview Farm corn mazes are never wasted. Each year the corn stalks are plowed under to replenish the soil, only to rise again the following year as a pumpkin patch for pick-your-own pumpkins. And when New Hampshire's winter finally puts an end to Riverview Farm's fall season, and Paul has plowed under the corn maze and the flower beds, Nancy closes down the stand, and the couple calls in the food pantries to make use of all the remaining good stock.

Families make an outing of apple picking and other activities at the farm

 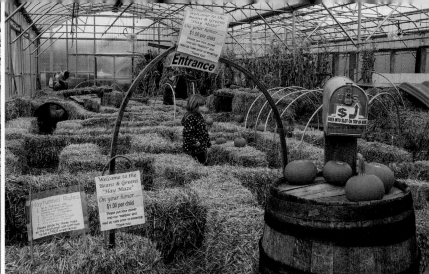

left Martina Howe *right* Hay bale maze

Martina Howe

BEANS & GREENS FARM, GILFORD

Over twenty-five years ago, Martina Howe, very pregnant, found that the vigors of field work limited her farm contribution to sitting by the roadside and selling sweet corn while her husband, Andy, chopped field corn. It was then that reality struck: "Andy was kept so busy restocking my supply of sweet corn that he was unable to continue harvesting the field corn! Our minds began churning with plans for a vegetable farmstand operation."

Although the land on which Beans & Greens sits has been farmed since the 1700s, those prerevolutionary farmers could never have imagined reaching the field production or realizing the business that Martina and Andrew Howe have achieved today. One visit will tell you that this couple knows how to profitably move a farm from the past into the present and on into the future.

Andy is the farmer, with 370 acres of vegetables, strawberries, flowers, chickens, and other animals to oversee. Martina is the agri-marketer extraordinaire, to the point

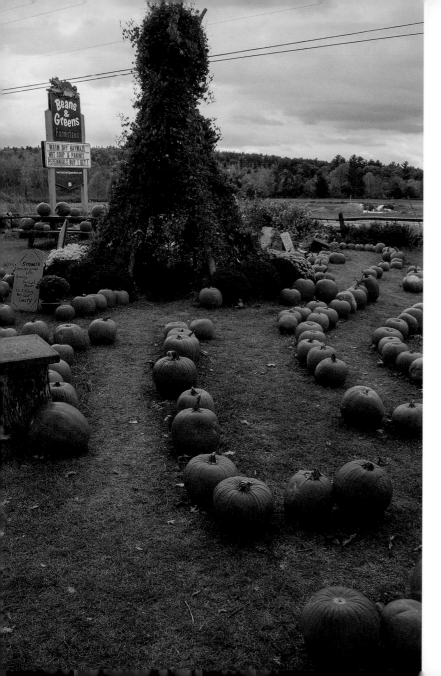

that today the farm is believed to have available the largest selection of products from a privately owned farm in the Lakes Region.

Although the heart of the farm will always be the growing and marketing of homegrown vegetables, beef, pork, and chickens through their retail store and year-round CSA, Martina has used her ingenuity to attract additional customers by overseeing a sizable food and baking production facility and by introducing farm-related activities such as animal petting, fairy house and flower arranging workshops in the spring, and pumpkin cutting and hayrides in the fall. To bring parents into the mix, there are happenings on many holidays, chicken barbecues with live dance music, and the more formal annual "Farm to Table Dinner" held in one of the farm's expansive fields overlooking the lake and mountains.

Martina's weekly e-news, suitably named "The Morning Rooster," announces all events, specials, and vegetable updates for this lovely New Hampshire "Farm of Distinction." These updates are also found on the farm's Facebook page and website.

During the busy spring flower season, Martina is around every day to offer advice on flower arranging and planting.

Pumpkin pathway and fairy house

Corn maze

Spring also includes the fairy house workshops—and they are not just for kids. The houses are created out of sticks, grass, gourds, moss, rocks, and whatever odd-looking objects can be scavenged from the farm's woods or fields. Constructing a dream "home for a fairy" brings out the unique imaginations of participants of all ages.

Visitors to the farm can pick up a delicious panini sandwich or salad in the farm's deli and relax in a large outdoor pavilion that is also used for children's birthday parties, barbecue events, and informal dinners.

In the fall, guests can spend an entire day taking part in family activities, which may include petting the farm animals, competing in an old-fashioned sack race, losing friends in the corn maze, or challenging them to hit the bull's-eye with a veggie slingshot. The corn maze, in the planning for months, is considered one of the state's most difficult. For the youngest generation there is a hay bale maze in one of the greenhouses.

All of these activities, and locally grown vegetables, flowers, and meats too, can be enjoyed on this New Hampshire farm in the Lakes Region.

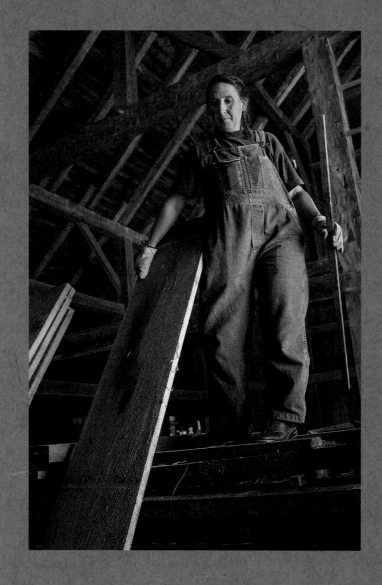

Focusing on a
Single Traditional
Farm Product

Christmas tree crop at Weir Tree Farms, Colebrook

WHILE FARMERS CONTINUE to discover better genetic varieties to improve crop production, and augment their farmstand offerings with value-added goods, there remain farmers who doggedly stay focused on preserving the integrity of a single crop—one that has been the staple of the area's farming community since precolonial days. Although these crops may be a farm's chief livelihood, they also represent an agricultural and farm family tradition that preserves people's access to and enjoyment of such products as maple syrup, honey, and milk.

opposite page Heidi Bundy stacking lumber at Tomapo Farm

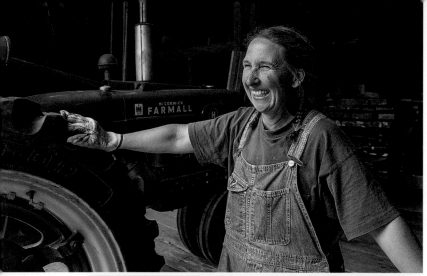

top Heidi Bundy *bottom* Heidi Bundy connecting maple sap lines with her father, Bruce Townsend

Heidi Bundy

TOMAPO FARM, LEBANON

Heidi Bundy has a lot to live up to. She is a member of Lebanon, New Hampshire's multigenerational Townsend family on Storrs Hill, which dates back to 1776. She is the granddaughter of Howard C. Townsend, commissioner of agriculture, 1972–1982, and the daughter of Bruce and Merinda Townsend, owners of the bicentennial Tomapo Farm. She modestly says she "keeps the books and does odd paint and carpentry jobs," but follow her around and it becomes obvious how essential she is to the family farm's daily operations. In early spring, she is in the woods tending sap lines for Tomapo's large sugaring business. During the summer, she is at the Lebanon farmers' market dressed in farm attire selling her syrup and maple candies. As time permits, to improve the sugarbush and to bring in extra income, she helps her father haul logs out of the woods before working the saw to turn them to lumber. And "because it fits into our schedule," she homeschools her five children. Young daughter Merinda's activities show that she is following in her mother's footsteps. She has started a honey and berry business.

top Sap collection site
near sugar house
bottom Heidi Bundy feeding
evaporator, "sugaring off"

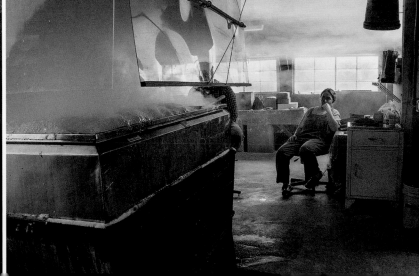

Sarah Costa

"Sure," says Sarah Costa of Winchester's Manning Hill Farm. "Sometimes I feel pity for myself, having to bundle up to go to the barn at zero degrees in the dark, but once I get there and watch the sun come up over the mountains while the birds chirp, I think, 'It does not get much better than this.'"

For the first four years of farm ownership, she worked full time to pay the bills as a sales manager for a local grain store, while partner Sam Canonica cleared land preparing for the arrival of their initial herd of nine Dutch Belted cattle. "It was a big decision to take the plunge and start milking cows from scratch, particularly in the current economy," she says. "But we knew we had to set ourselves apart from other dairy farms, so we decided to milk the rarely seen Dutch Belted dairy cows." Not to be confused with the Belted Galloway cows that are raised for beef, the Dutch Belteds are a rare breed, numbering fewer than three hundred in the United States. Establishing a "breed-

left Milking herd *right* Sarah and
Sam Canonica, bottling milk

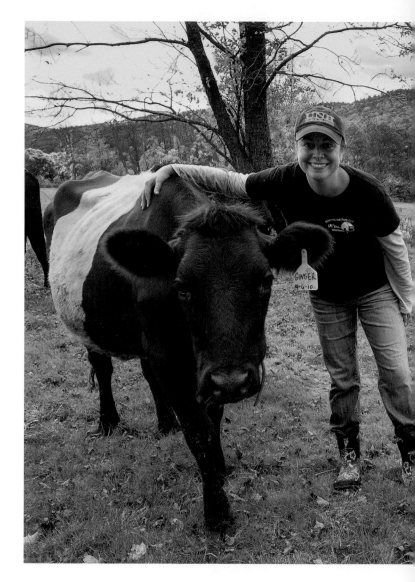

52

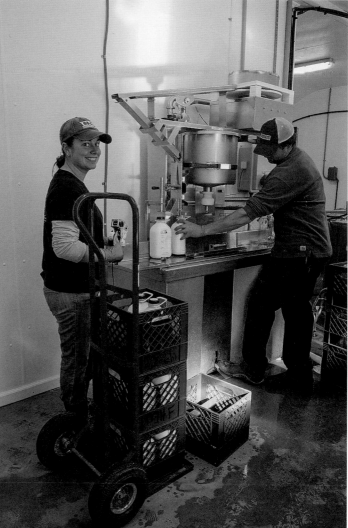

Wrapped round hay bales at Manning Hill

ing-up" program is a part of Sarah and Sam's business plan to make a contribution to farm animal conservation.

In 2010 Sarah resigned from her job and began milking the cows. She arises at 5:30, puts on her sweatshirt, jeans, and muck boots and, with a cup of coffee in hand, heads for the tie stall barn, built in the late 1800s. Impatiently waiting at the end of the tunnel to the milking area is the first string of eleven cows (of twenty-five) to be milked. Some may kick a bit, but her favorite, named "Love," born in 2011, offers licks of affection as Sarah wraps her arms around the animal and gives it bear hugs. "She's goofy-looking, really sweet with big ears, big horns, and she never kicks, which is always a plus."

Sarah milks her charges twice a day, at 6:00 a.m. and 6:00 p.m., and bottles the milk twice a week. The milk is stored in the farm's state-inspected and federally inspected milk bottling plant where she, with the help of Sam, processes and bottles the milk on Tuesdays and Thursdays. "Unlike commercially pasteurized milk, ours is gently pasteurized in small batches at 145 degrees for thirty minutes, then quickly cooled down to below 45 degrees before bottling." Low-temperature pasteurization preserves as many nutrients as possible without creating any health risks.

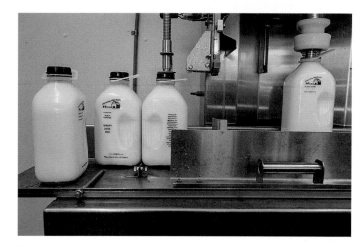

Fresh milk

In between milkings and bottling, she stocks product in the farm store, bottle-feeds the calves, cares for the pigs, feeds and gathers eggs from the 430 laying hens, does the bookkeeping, and markets the farm.

One Memorial Day after a milking, a guest asked if she was going to take a breather for the holiday. "No, no," she responded, "I have to finish packing eggs for the Monadnock Food Co-op and get ready for the next Keene farmers' market."

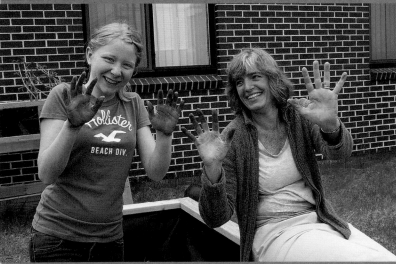

Educating
Children,
Adults, and
Politicians

SEVERAL YEARS AGO, a visitor asked Diane Souther, owner with husband Chuck of Concord's Apple Hill Farm, if she could join a wagon ride with some elementary school students. In half jest Diane said, "You are too old; you already know what you like to eat. It's the children we must educate."

The number of programs for educating children about where their food comes from increases each year, and most are managed by women. Examples include the Farm to School Program sponsored by the University of New Hampshire's Sustainability Institute and Agriculture in the Classroom program, under the umbrella of the New Hampshire Farm Bureau's Associated Women.

The mission of the Farm to School Program according to Stacey Purslow, program coordinator, is to promote long-term health and nutrition among the younger set. She believes that "the more a child is involved with food through gardening, farming, cooking, or other 'real life' food experiences, the more likely he or she will adopt healthy eating behaviors as a lifelong practice." The pro-

gram encourages school administrators to buy directly from a local farm or a local produce distributor for their school meals and to organize field trips to farms so that the children can observe how and where the food they eat is grown. Some schools have even ventured into the realm of vegetable gardening.

The Agriculture in the Classroom program, rather than working toward putting more farm products in school cafeterias, seeks to educate students and teachers about daily life on a farm, farmwork, and the food that comes from it. A monthly instructional bulletin offers teaching aids, and, in the spring, farmers visit the schools to put a face on farming. For city children, meeting a farmer and hearing about his or her work with soil, animals, bees, and plants is a new experience.

Parent fundraising through community-supported agriculture (CSA) programs encourages families to sign up for produce deliveries to the school, where children will see and experience farm deliveries and pickups. A percentage of the farm's profits go to the parents' association. School gardens, harvest meals, signage in the cafeterias, and community gardens are all further efforts to educate children and adults about locally grown food.

opposite page Kat Darling (top) training Proctor Academy students at Two Mountain Farm, Andover; Stacey Purslow, (bottom) Farm to School Program Coordinator, training student at elementary school, Seabrook

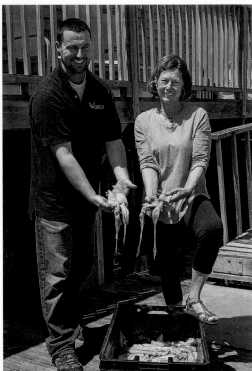

Padi Anderson

F/V RIMRACK AND GRANITE STATE FISH, RYE

With a career path centered on the fishing industry, Padi, a handsome woman in her sixties, is well known around the commercial fishing harbor in Rye, New Hampshire. First came a lobster and fishing store, then two charter boats—the *Atlantic Queen* and *Captain Mindys*—and a bait and tackle business to supply the boats, all before her future husband, Mike, with the *F/V Rimrack* (*F/V* stands for fishing vessel), entered the scene to lease her extra mooring. Mike is the skipper of the *Rimrack*, the largest vessel in the harbor and for which Padi now runs the administrative office. She coordinates between landside and boat and orchestrates maintenance, supplies, and sales.

As with most of the state's agricultural endeavors, the fishing business is diversified and seasonal. "Like a garden, some species are only available at certain times of the year," says Padi. The *F/V Rimrack* is the only boat out of Rye Harbor Marina that is rigged as both a "gill netter" and a "dragger-crawler," making it equipped to fish year-round. All of the ten New Hampshire–based fishing boats, except the *Rimrack*, are only gill netters, which catch "ground fish" such as pollock, cod, haddock, and red snapper, and they fish only during the summer months.

"Rimrack" is a nautical term meaning the net rim racked or hung up on the bottom and a total loss. As a dragger-crawler, the *Rimrack* can drag along the bottom to get scallops and flounder.

In 2010 Padi, in an effort to keep the New Hampshire fishing industry a local and community-based business, established Granite State Fish as a nonprofit fishing industry organization "based on principles of ecological responsibility, economic sustainability, community stewardship, and healthy food systems." Its goal is to integrate the often forgotten New Hampshire fishing industry into the state's food system in three ways, or, as Padi says, three "layers of access." The first layer is based on the consumer-supported fishery model. Here Padi visualizes applying the ground-based model of consumer-supported agriculture, where local products have drop-off points for consumers. The

opposite left Padi Anderson at Sanders Fish Market, Portsmouth
opposite top and bottom Squid catch delivery from *F/V Rimrack* retail sales at Sander's Fish Market

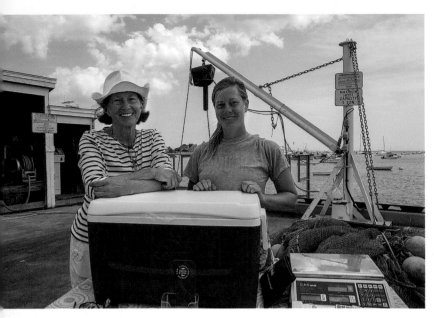

Padi Anderson and her daughter Kelsea selling scallops from *F/V Rimrack* off the Rye Harbor dock

second layer of access is centered on local seafood markets in the seacoast area, and the third on the dock as she sells scallops depending on supply—by order only.

She agrees that preserving the local fishing industry is an uphill battle, as fishermen retire and younger men do not want or cannot afford to move into the business. "The government licenses being bought, sold, and leased are at such exorbitant amounts that they are beyond what the local fisherman can pay, and there is no guarantee of a profitable return." "Consolidation," she adds, "is the government's way of feeding more people, but large fleets are less flexible. Similar to local farms, small fleets are easier on the environment and can react and adapt to environmental and food security problems more quickly."

Granite State Fish is making every effort to band a local industry together. "We are, after all, part of the New Hampshire food system," says Padi. "Our fishing communities also mean New Hampshire communities."

Diane Souther

APPLE HILL FARM, CONCORD

Diane Souther looked faintly bemused when asked by a visitor what her job was on the farm, but with only the slightest pause she responded, "Accountant," then "advertiser, planter, grower, human resource officer, specialty food manufacturer, marketer, designer, and everything else that comes with a small business." Despite her formidable list of duties, what Diane did not mention was her role as a teacher—to students, to customers, to farmworkers. Such mentoring gives her farm a loyal following.

Before beginning a tour of the orchard for school groups, day care groups, and homeschoolers, she says to a bystander, "I always keep in mind that the parents usually need as much education about growing apples as the children." She begins with a brief account of why the apple tree leaves are green (photosynthesis). Students watch the bees buzzing around, pollinating the apple blossoms before returning to their hives, and she notes the importance of not only the bees but the beekeepers who bring their hives to the orchard. Hanging from several trees, and inevitably catching the children's eye, are unusually large red apples,

Diane Souther with apple pies for the farmstand store

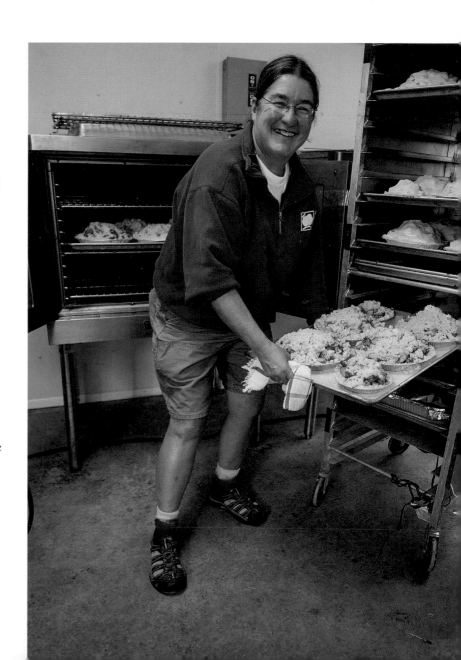

House above the farm

left Outreach to military families *right* Ski gondola turned apple icon

but they are not for eating. These apples are covered with a sticky substance to which a variety of insects have become firmly affixed for future monitoring and identifying. There are also a variety of insect traps hanging among the trees. All are part of Apple Hill's integrated pest management program the farm conducts with the University of New Hampshire to reduce the use of pesticides.

Students occasionally are invited to get their hands dirty and plant seeds at Apple Hill Farm. Canterbury Elementary School's fourth and fifth graders attend a weeklong environmental camp. Says Diane, "They plant pumpkins

in the spring, weed during the summer, harvest and sell in the fall. It becomes a full family project with parents and siblings taking part, and the profits help to offset the cost, making it possible for the entire class to attend."

Early on, Diane realized that her farmworkers, hard-working though they may be, needed guidance. Some college students who live in the cities do not know that carrots and potatoes grow underground. "They don't have home gardens," says Diane. "And I had never thought about it." She educates the workers to be her first line of defense against pests and disease in the fields. "I have

left Diane Souther and student work crew *right* Collecting insects for integrated pest management research

trained them to be my scouts for strange insects and fungus, and they watch for changes in plant structure to report back to me." With each year, returning workers learn more, and, she says, "it is not unusual for a college student to change a major course of study after working on the farm."

Teaching how to prepare the farm's fruits in dishes that take advantage of their just-picked flavor is one of Diane's most significant accomplishments. She has a crew of well-trained (by her) cooks in the kitchen of the farmstand, and she appears on New Hampshire station WMUR's *Cooks Corner* four times a year during the growing season to prepare dishes and to stress that "your neighbor's farm-grown food leads to the most flavorful and healthful dishes."

Clearly, one can see why Diane Souther might have been taken aback by the question of just what her duties are on Apple Hill Farm.

Apple Hill Farm Rhubarb Squares

Rhubarb is the first sign of the growing season on Apple Hill Farm. This is a recipe Diane presented on WMUR in 2013. She suggests mixing the rhubarb with the farm's strawberries when they ripen in June.

TOP AND BOTTOM LAYERS

1 cup flour

¾ cup oatmeal (uncooked)

1 cup brown sugar (packed)

1 tablespoon cinnamon (Diane uses 2)

½ cup butter — softened

FILLING

2 cups diced rhubarb (approximately ½-inch slices)

¾ cup sugar

1½ tablespoons flour

¼ teaspoon nutmeg

1 tablespoon butter (softened)

2 eggs (beaten)

DIRECTIONS

Preheat oven to 350 degrees

Mix ingredients for top and bottom layers. Blend together the 1 cup flour, ¾ cup oatmeal, 1 cup brown sugar, 1 tablespoon cinnamon and then stir in the softened butter. Use a deep 8- or 9-inch square pan and divide the mixture into 2 portions. Press half the mixture into the bottom of the pan and save the second half for the top.

Over this bottom layer spread out 2 cups diced rhubarb. In a separate bowl stir together ¾ cup sugar, 1½ tablespoon flour, and ¼ teaspoon nutmeg. Beat the 2 eggs in a small bowl and add to the flour/sugar mixture, add the 1 tablespoon of softened butter, and stir until well blended. Then pour this mixture over the top of the rhubarb in the pan.

Spread the remaining oatmeal mixture over the top and pat down slightly. Bake in 350-degree oven for 25 to 30 minutes until lightly browned. Let cool slightly; serve warm or cool. Great topped with vanilla ice cream.

Building Tourism

*Farm Days, Fairs,
and Food Trails*

"AGRITOURISM," as generally defined by government statisticians, refers to agriculturally based entertainment that generates supplemental income for the owner of a farm. Other names are "agri-entertainment" and "agrotourism." Although we think of "agritourism" as a relatively new term referring to a way of improving the profit margins of farmers, its "history dates back to the late 1800s when people leaving the cities would come to visit relatives on farms to escape urban life," according to a research paper issued by Louisiana State University. With the development of the automobile, even greater numbers of visitors traveled to rural settings for relaxation, and more formalized and varied activities began to be publicized.*

In New Hampshire, the growth of agritourism has increased more than tenfold in the past ten years and covers a broad swath of on-the-farm activities. The benefits to the farmer range from an increase in cash flow to an opportunity to share a farming passion with visitors.

Walpole Valley Farms in Walpole features the Inn at Valley Farms, which invites visitors to enjoy a lovely meal and even participate in farm activities as a way of having "the farm experience," says innkeeper Jackie Caserta. "And it really is an educational one, particularly for children." Many farms offer "farm days" that include egg tosses; ice cream cones; petting chickens, cows, and pigs; wagon and sleigh rides; and even churning "butter in a jar" to show how cream was made into butter years ago.

Some farms expand their agritourism activities each year. At Beans & Greens Farm in Gilford, Andy is known as Farmer Andy and Martina manages a growing number of tourism attractions, as well as the weekly newsletter "The Morning Rooster."

Other farms focus on a particular season and stick with annual activities that returning visitors have come to expect and enjoy each year.

County fairs and festivals are agricultural events that attract large numbers of visitors from in and around New England and are an important way to educate them about farm life. City and urban dwellers enjoy wandering through the event grounds to check out competitions that feature farm products ranging from pickles to hand-knit sweaters made from a farm's own wool. Farmers readying

opposite page Trying out the tractor on Farm Day, Walpole Valley Farms, Walpole

* Dora Ann Hatch, *Agritourism: A New Agricultural Business Enterprise* (Baton Rouge: Louisiana State University, 2008).

their animals for competitions are open to conversations with anyone walking by. Fairs are also a great opportunity for children to speak with their peers, as 4-H members groom their beloved animals in preparation for showing off their physical appearances and performance in the ring.

The concept of agritourism includes the many new product trails that New Hampshire's Department of Agriculture, Markets & Food has developed with the state's Division of Travel and Tourism Development to encourage travel around the state. On the Wine, Cheese & Chocolate Trails, one of the "must" stops is Doug and Debby Erb's cheesemaking facility, where visitors can watch the famous Landaff Creamery's Welsh-style cheese being made. Though the shop is always open, the cheese is made only twice a week, so it is best to call before visiting.

The Ice Cream Trail, one of the most popular in the state, features the ninth-generation Beech Hill Farm Stand and Ice Cream Barn in Hopkinton, near Concord. The 1800s farm has been retrofitted by the multigenerational Robert Kimball family as an ice cream barn, country store, gardeners' barn, and farm museum.

Walpole Valley Farms and the Inn at Valley Farms, Walpole

Children in an egg toss contest on Farm Day

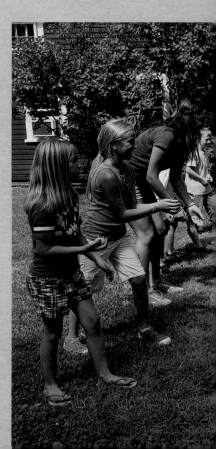

Jackie Caserta and her mother,
Bonnie, on Farm Day

Dining table
set for breakfast

Dairy equipment
behind the long barn

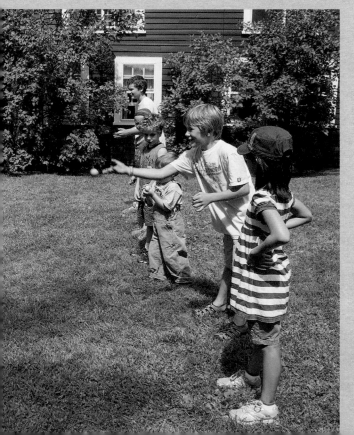

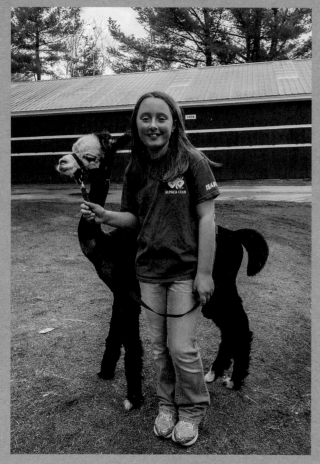

Girl-size alpaca and 4-H youth at the fairgrounds

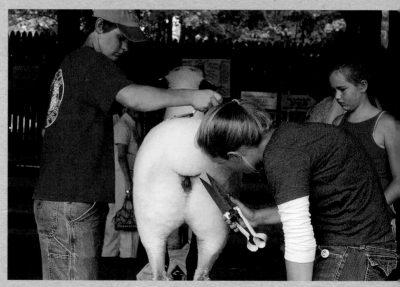

top Hooves being polished for showing by 4-H member
bottom Precise grooming for show by 4-H youth
opposite page 4-H youth awaiting animal judging at the fair

Cornish Agricultural Fair,
Cornish

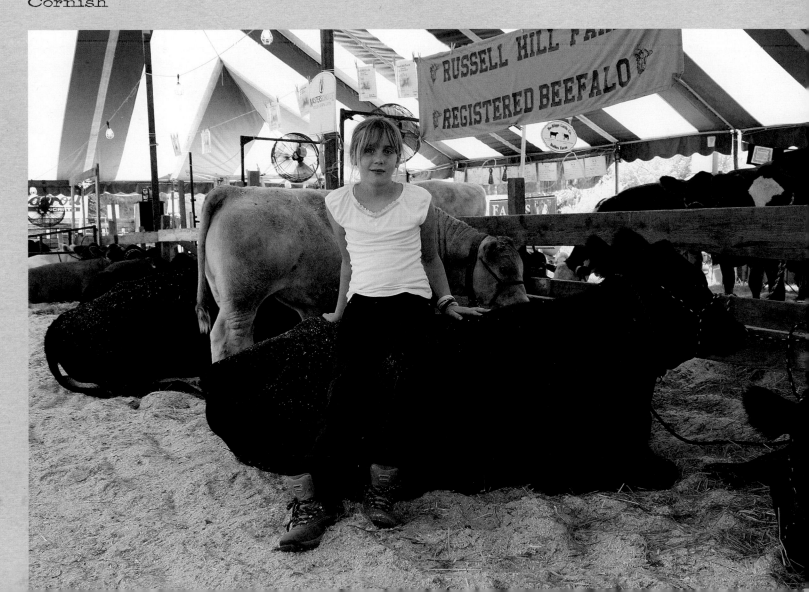

Dairy barn

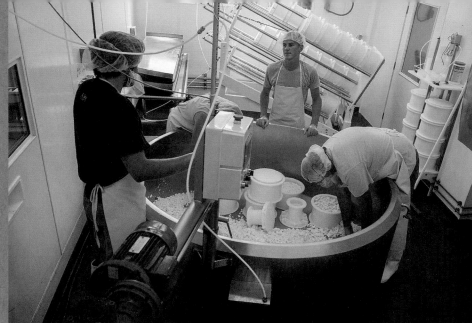

above Workers making cheese
left Debby Erb with weaning calf
at the creamery

New Hampshire's
Wine, Cheese &
Chocolate Trails:
Landaff Creamery,
Landaff

New Hampshire's Ice Cream Trail: Beech Hill Farm and Ice Cream Barn, Hopkinton

Three generations at Beech Hill: Donna Kimball, Holly Kimball Rhines, and her daughter, Megan

Farm animals as an attraction at the farm stand for families following the Ice Cream Trail

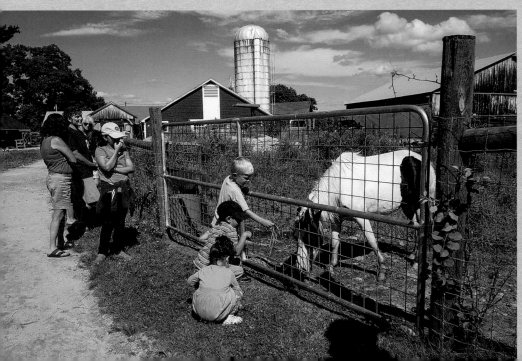

Family eating ice cream at Slick's, Woodsville

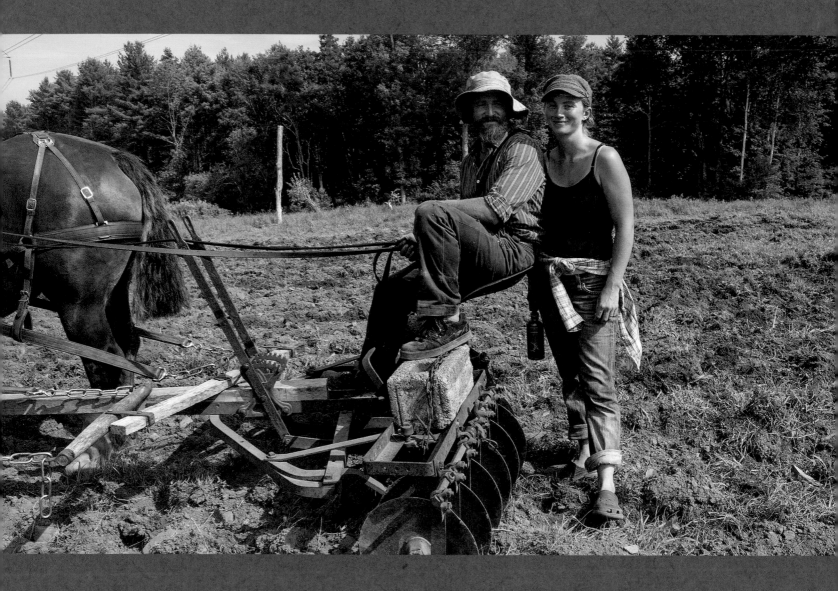

Women LAND PRESERVATIONISTS, WORKING FARMLAND

FAMILY TRANSFERS OF LAND that involve land conservation generally fall into two categories: (1) the older farming generation intends to pass the land to the next generation but does not trust the younger generation to keep the land intact and in active managed farm use, given the appreciation of land values; and (2) the older generation has already passed the farm to the younger generation, and both generations wish to pursue conservation options for financial benefits that come from selling the conservation easement.

"Decisions to pursue land conservation options are more and more the result of a significant life event in the family (death, illness, injury, a change in farm dynamics). Much of the land conservation that was motivated by pure desire to protect the land has taken place over the past few decades and is less and less frequent," says Ian McSweeney, executive director of the Russell Farm & Forest Conservation Foundation.

opposite page Annalisa and Joel Wild Miller preserving agricultural land, Wild Miller Gardens, Lee

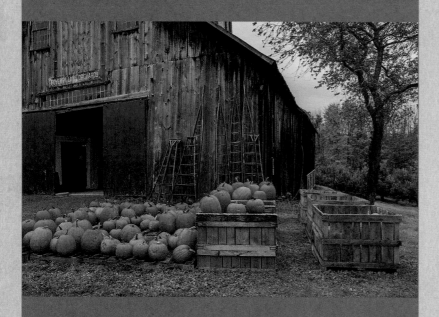

Autumn barn, Poverty Lane Orchards & Farnum
Hill Ciders, Lebanon

Keeping Family Land Productive

Icelandic sheep at the Patridge farm, North Haverhill

AMONG NEW HAMPSHIRE's land preservationists are those who are carrying on the family tradition of a working farm. If their land has not been put under a conservation easement by an earlier generation, an easement is usually under consideration by the current owner. Ian McSweeney comments that he has noticed "a striking gender difference in the younger generation's intentions and goals for their parents' land. Women nine out of ten times are the ones who want to conserve their parents' land for a variety of reasons that range from the need to financially care for their parents, create a legacy for their family property, fulfill parents' wishes to protect the land, and/or have the farm remain a farm, generating revenue to pay off debt, which may allow the farm to be expanded, maintained, or diversified. These are all benefits and reasons for conserving the family farm."

top Mary Jones *bottom* Patridge farmhouse overlooking Vermont

Mary Jones

PATRIDGE FARM, NORTH HAVERHILL

Mary Jones's grandparents, Harry and Maude Patridge, made their living as dairy farmers, sold eggs to neighboring stores, and during sugaring season, with the help of a team of horses, made maple syrup. Her father, Francis, when he returned from World War II, took over the farm with his new wife and built a wing on the farmhouse. With the 1970s downturn in the dairy market, he, like many others, was forced to sell his herd and equipment at auction and lease out his land for grazing and haying. To make ends meet, he drove a school bus and eventually became a full-time mail carrier.

Mary delights in speaking of Francis's raspberry patch and flower gardens with the cosmos flowers "as high as the sky." The gardens surrounded the original large, white, shingled farmhouse with a wide wraparound porch overlooking the hills into Newbury, Vermont. Today's house, a smaller version, was rebuilt in 2000 after the first house was destroyed by fire and is the one Mary and her husband, Bruce, live in today.

With the death of Francis at the age of ninety-one, Mary took on full responsibility for the 154-acre farmland

with Bruce and began returning the land to the working farm it once was.

Mary says, "In 2007, we purchased two heritage Tamworth piglets from Hogwash Farm in Norwich, Vermont, to grow out for meat." With a smile she adds, "We ended up keeping Tilly to breed and bought two more Tamworth pigs, and the farm was back in business. Thinking back, when we had two little piglets on the farm, we spent hours with them. At sunset we would take chairs and a glass of wine and sit in the pen with them. Now, with a whole barnyard of poultry and animals, it seems we have no time to ponder at the end of the day; one day just rolls into another."

Mary believes all the farm's animals should live outside in their fields, and all are certified organic by the New Hampshire Department of Agriculture, Markets & Food. "Organic practices and the humane treatment of animals are a way of life on our small farm," she says.

The farm's greatest emphasis is on raising heritage breeds for meat and for breeding. The Livestock Breed Conservancy and the Slow Food's Ark of Taste are their major informational sources. Today the couple raises poultry, sheep, and pigs.

In 2009 Mary began raising Pilgrim geese, which the

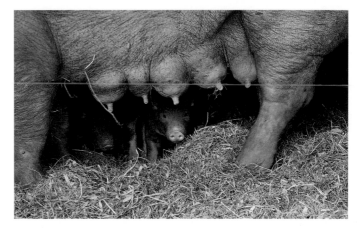

Nursing piglets

Conservancy lists as "critical," meaning in danger of extinction. As medium-sized farmyard geese, they are named after a family's pilgrimage to Missouri during the Depression. "I'm happy to have this breed on the farm, as they are good-natured, calm, quiet, and very personable. They also are easy on the land, having contributed greatly to making our pastures lush." Steeped in historical tradition, goose has been the meat of choice for centuries by many families on Christmas and is one of the farm's most popular sellers. Mary always reminds buyers not to discard the goose fat. "It roasts potatoes to a golden crisp color and makes a good frying medium." The goose eggs sell well, too, and

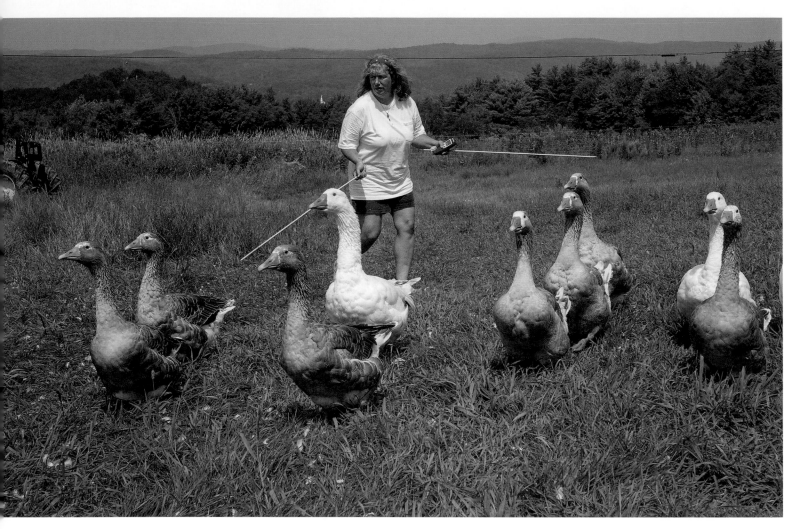

Mary Jones herding goslings

even the feathers are in demand, as a local potter, Bruce Murray of Bradford, Vermont, uses the quills to draw on his pottery.

Other poultry on the farm include Gourmet French Pekin and Duclair ducks. Duclairs, a rare heirloom breed, are known for red and dense meat. Chickens and Thanksgiving turkeys complete the family poultry yard.

Icelandic sheep are relatively new members of their farm. With 1,100 years of history, they are one of the world's oldest breeds, and though Mary sells them for their tender and lean meat, their fleece is also available for sale, as are the animals for breeding purposes.

And so you might ask, does Mary still raise pigs? "Oh yes," she says. "We sell them as custom cuts of pork along with whole and half hogs."

Farmstand bounty at McLeod Bros. Orchards (*see page 82*)

Kris Mossey

Kris Mossey's family farm in Milford dates back to 1946 when her grandfather, Donald McLeod, graduated from the University of New Hampshire with a major in animal husbandry and, after working at a desk for a few years and deciding that the sedentary life was not his want, pur-

82

Apple harvest

chased what is now the McLeod Bros. Orchard in Milford, New Hampshire.

The name "McLeod Bros. Orchards" came to be when Donald's brother Kenneth, a U.S. Navy pilot, teamed up with him after the service.

After Donald McLeod died in 1991, his wife, Valerie, continued to farm. Today she, with the help of her family, oversees a ten-acre parcel of their two hundred acres and takes care of the books. Kris handles the majority of the hands-on farm work and manages day-to-day operations, while her sister, Becky, and other family members perform vital tasks, particularly during busy times. Husband Rick admits that his wife "is at heart a real woman farmer from New Hampshire."

Although apples continue to be their premier crop, in the 1980s, when orchards began moving away from whole-saling and controlled air storage sales, "to remain profit-able," says Kris, "we had to diversify what we were doing."

They have extended their growing season to accommodate summer vegetables, a small peach orchard, and a greater variety of apples. The farm's produce is available at the Bedford farmers' market, through a community-supported agricultural (CSA) program started several years back, and in the fall at their pick-your-own apple operation.

Kris Mossey

The farmstand as a
family attraction

Wagons for transporting pick-your-own apples and kids

Growth in sales and customer tastes have forced the farm to expand its choice of offerings. "Our customers like variety," Kris says. "It's fun to spend a winter night deciding what new ones to grow the next season. We are even beginning to grow potatoes." With a wider range of vegetables, she finds that customers like knowing that they do not have to go to the regular market.

Kris's engaging personality shines at the farmers' market and the farmstand and makes it easy to understand why she was once president of the New Hampshire Farmer's Market Association and moved on to become chair of the New Hampshire Made board of trustees. "Farming is a lonely business," she says, "and it is enjoyable working with differ-

ent organizations and going to the farmers' market to talk about what you do. It is at the market that the customers and farmers get to know each other." Customers at the farm and those at the market differ, and each have their own reasons for shopping the way they do. Nonetheless, she tries to get farmers' market families to enjoy her new post-and-beam open farmstand and have a family day picking apples.

In the end, Kris says, "apples are our way of life; we cannot imagine not growing apples. Our children [her son and daughter and Becky's daughter] love the farm. As they get older and talk about what should be done differently, we know we must listen, as it is important to foster their continuing interest in the farm."

Building Food
Self-Sufficiency

MANY OF TODAY'S NEW HAMPSHIRE FARMERS, men
and women, are graduates of the University of New
Hampshire, where they have been educated in the biologi-
cally and economically diverse farming methods necessary
to increase the amount of food grown and consumed in the
state. Waste recycling, integrated pest management to re-
place harmful pesticides, plowing under crops to replenish
the soil, water cisterns, wind and solar power, leaving land
fallow for a time to restore itself, and organic fertilizers are
examples of efforts to create a more efficient and self-
sustaining farm.

In a small farm that features a diversity of crops, unlike
a one-crop factory farm, the farmers are in control of all
aspects of their growing business and can make quick ad-
justments to local consumer trends and demand, climate
conditions, and marketing methods.

Out of concern for their children's future and that of
their neighbors, women gravitate to working on local farms
to ensure a food-secure community, a healthy lifestyle, and
a well-rounded diet for their family. In helping with this
effort, the New Hampshire farming community is fortu-
nate to have the support of the University of New Hamp-
shire Sustainability Institute, which is the oldest endowed,
university-wide sustainability program in U.S. higher
education.

Chickens outside their mobile-home coop at
Haynes Homestead, Colebrook

opposite page Variety of farm animals at
Haynes Homestead, Colebrook

Tracie Loock

TRACIE'S COMMUNITY FARM, FITZWILLIAM

While studying environment horticulture at the University of New Hampshire, Tracie Loock had dreams of farming her own land. In 2007, after nine years of building a CSA program on her father's farm, she had honed her farm management skills and was ready for bigger things. With the help of family, friends, and neighbors, her greenhouses, perennial plants, and equipment were transported to their permanent home on 33 acres of conservation land in Fitzwilliam. With the addition of a barn and farmstand built from pine harvested and milled on-site and new greenhouses, she has been able to build her CSA membership to the point where it is one of the largest in the state supplying organic vegetables to her community.

By adding compost and other organic amendments to the soil, she strives to create the most nutritious vegetables possible for her CSA members, wholesale and farmstand customers. To protect the surrounding environment as well as her workers who come in contact with the farm's vegetables, she does not use herbicides, chemical insecticides, or fungicides. Pest problems are prevented through crop rotation, the use of row covers, and timely cultivation.

Tracie Loock (center) and staff enjoying a communal homemade lunch

Cover crops prevent erosion, add organic matter to the soil, and capture nutrients that would otherwise be lost to leaching.

To further her effort to make a more food-self-sufficient community, Tracie encourages other farmers, established and new, to use her farmstand as a sales outlet for meats, baked goods, syrups, jams, cheese, and ice cream. Her work

left Tracie's Community Farm as CSA pickup and local food hub *right* Swap table

is reflective of other regions of the state where local food hubs are developing as food distribution centers or local farms are forming partnerships to expand their distribution possibilities. By making products grown in the community more accessible and more economical to transport, flavorful, fresh, and vitamin-packed food is now appearing on restaurant menus, in town markets, and on family tables.

Although she is committed to providing her rural community with access to good-tasting and healthy food, Tracie understands that she must also run a viable business and set goals for herself. Her first goal was moving off her father's land to a bigger place of her own. Continuing to increase the size of her CSA is part of her plan. Most recently, her objective has been to become a better employer.

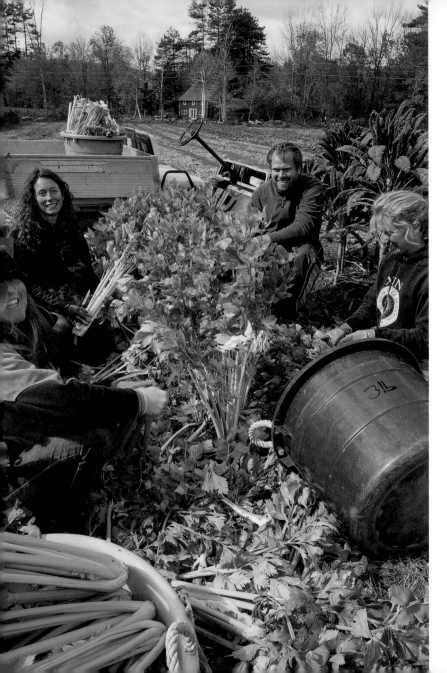

left Celery harvest *above left* CSA baskets
above right Extending the season for the CSA with fall crops

Two women are now helping to manage the farm; both have been working at the farm for four seasons. Sarah Wilson is the barn and office manager, and Kristen Wilson is the assistant manager. Six full-time workers plant, hoe, harvest crops, fill CSA baskets, stock the shelves, and do maintenance work. "I really want this farm to be economically sustainable, but at the same time I need to be able to keep trained workers. I must make it possible for them to return each year," Tracie says.

Elaine Haynes

HAYNES HOMESTEAD, COLEBROOK

The original Haynes Homestead began as a dairy farm, and Elaine and husband Haven continued in that tradition by milking sixty Holsteins. With the downturn in milk prices and an injury to Haven, the couple decided to sell the herd in the 1980s and switch to Herefords for beef. "But then in 2000, we got out of that," sighed Elaine. "Too much work for little reward."

So going back to the way the farm had begun in the lean days of the Depression, Haven and Elaine began putting

above Calf among herd *right* Elaine Haynes picking strawberries

Cone used for retaining warmth for North Country crops

a portion of their 400 acres back into becoming the fully self-sustaining and diverse farmland it once was.

With her motto, "A body at rest stays at rest," this seventy-year-old woman, whom everyone calls "Grammy," rises at five in the morning, has a cup of coffee and one of her homemade muffins, and then goes to the greenhouse, where she picks or washes greens with what she proudly calls "my commercial spinner from Johnny's Selected Seeds catalogue." The schedule is set. "Monday and Wednesday is cutting. Tuesday and Thursday is washing."

As with any working person, midmorning signifies a break, and Elaine makes a smoothie of kefir mixed with blueberries, apples ("actually any fruit"), frozen bananas, chai, eggs, and goat's milk, and she brags that "all but the bananas, kefir, and chai are off the farm." Other favorite drinks range from chocolate whey to wheatgrass juice powder mixed with water. There are many imaginative concoctions in her repertoire, as she conjures them up from the homeopathic ingredients she sells at her farmstand.

"I have never gotten used to sitting down," she says, so her midmorning breaks do not last long before she is on the go again. Adding an aside that no young person works today as much as she and Haven with their six boys did, she continues, "We were in the barn with the boys before school and after school." Haven confirms, "Nobody works today." Their house, Elaine says, "is always open to helpers—from our grandchildren to others." Her granddaughter moved up from North Carolina to help pick strawberries but moved back "because it was too cold up here."

Fruits and vegetables are not her only charges. There are guinea hens, pigs, piglets, goats, cows, and chickens that produce twenty dozen eggs a month, which bring in revenue but little net income. "It really is the culture and the experience that raising chickens brings," she says. "Fences, henhouse, food, and other items require money, and chickens don't even produce eggs for nine months. No one gets rich on selling eggs," she adds. "To recover cost, I would have to charge five dollars a dozen and customers will not pay."

Showing a deep interest in farming beyond that of her own farm, "Elaine has been the 'mover and shaker' for agri-

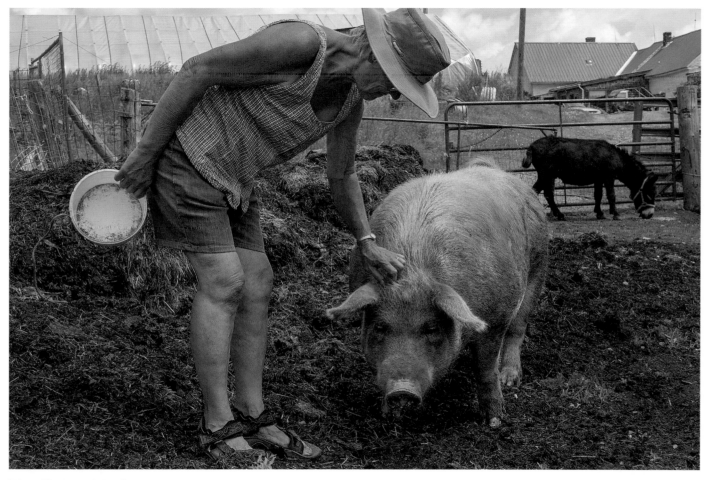

Elaine Haynes with her favorite pig

Haynes Homestead store with tractor

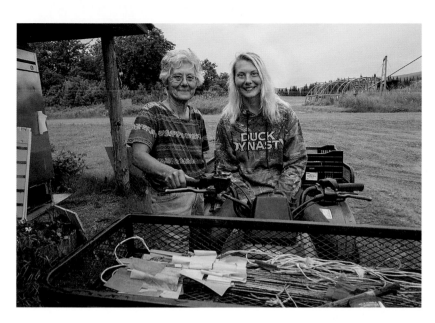

Elaine Haynes with her granddaughter, Nicole, who helps out on the farm

culture in the North Country," says Julie Moran, president of the North Country Farmers Co-op. "When I moved to Colebrook in 2007, Elaine was looked at as the premier grower in Colebrook, and as a new resident I needed her to give me credibility among the farmers to get the Co-op organized." Julie's suggestion of a feasibility study was quickly nixed by Elaine with a "let's just do it" attitude. "Elaine ran circles around everyone and a group was formed within a matter of months," says Julie.

Today in the North Country, the Co-op is only one sales outlet for Elaine and other farmers. Haynes Farmstead products are available at five locations. "It's like investing," says Julie. "You must spread the risk." Elaine delivers to thirty CSA members each week; she sells at two farmers' markets, at the North Country Marketplace & Salvage, and at her farmstand. "What sells at one place may not sell at another," she says. "I try and cover all possible markets and it is the diversity of my farm that allows me to do that."

And does this seventy-year-old woman have goals for the future?

"Oh, yes," she says. "I'm really excited about growing wheat. This winter I'll experiment with it in different recipes."

Women OFF-THE-FARM SUPPORT

SPARE TIME IS SPARSE FOR FARMERS. In spring, it's plowing, planting, and weeding; in summer, picking and selling; in fall, plowing, fertilizing, and planting cover crops. Come winter, supplies need to be ordered and then, maybe, there is time to take a two-week vacation. Farmers have little opportunity to "toot their own horns." Thankfully in New Hampshire there are many organizations—state, nonprofit, and volunteer—that promote New Hampshire farms and the high-quality food they provide.

At the local level, in some New Hampshire towns agricultural commissions serve as a local voice advocating for farmers, farm businesses, and farm interests. Or a spontaneous group may form to speak up for threatened farmland.

Few legislators are versed in the business of agriculture and farming. As bills that have an impact on local farms come up before legislative committees, representatives of the New Hampshire Farm Bureau are always on hand to educate and update their local government representatives by phone or in person.

At the state level, the major marketing and promotion of New Hampshire farms fall on the shoulders of the Department of Agriculture, Markets & Food. Critical to farmer and consumer education are the Cooperative Extension Services, which fall under the umbrella of the University of New Hampshire, a land grant university.

Known for its frugality (tight finances), New Hampshire also relies on special-interest groups, volunteer organizations, and local co-ops for help in promoting its rural economy and agricultural efforts. Below are only a few of those organizations and people who support New Hampshire agriculture from their offices.

opposite page Julie Moran making the rounds for North Country Farmers Co-op with Kevin Hurley of Hurley's Honey, Colebrook

AGRICULTURAL MARKETING FOR STATE GOVERNMENT

GAIL MCWILLIAM JELLIE | *Director of Agricultural Development, New Hampshire Department of Agriculture, Markets & Food*

left Gail McWilliam Jellie
below Conducting a workshop for Farm to School Program

The Division of Agricultural Development works to inform the public of the value of the New Hampshire agricultural industry, to contribute to the understanding of its diversity of businesses and products, and to encourage the purchase of local agricultural products. It also creates and promotes market development opportunities for New Hampshire agricultural producers.

When she is in her office, a question to Gail McWilliam Jellie never goes unanswered. Outside her office she serves on many state boards focused on marketing New Hampshire's agriculture. Former commissioner Stephen H. Taylor, who appointed Gail in 1993, comments that she has a "remarkable talent for partnering the funds and groups necessary to further the development of agriculture in the state."

EDUCATIONAL EFFORTS

Schools

STACEY PURSLOW | *Farm to School Program Coordinator, Sustainability Institute, University of New Hampshire*

The New Hampshire Farm to School Program (NHFTS) encourages and facilitates the adoption of farm-to-school practices by farmers, distributors, food service directors, teachers, health educators, and administrators. The NHFTS began as a pilot program in 2003 to introduce local apples and cider to New Hampshire K–12 schools. Within three years, more than half the schools were participating.

Stacey Purslow joined NHFTS in 2009, and her background is remarkably diverse. She has a degree in photography from the Corcoran School of Art in Washington, D.C., has worked at a variety of jobs in the food service industry, trained in the University of New Hampshire Cooperative Extension Master Gardeners program, and graduated from the university's Thompson School, where she studied nutrition and dietetics.

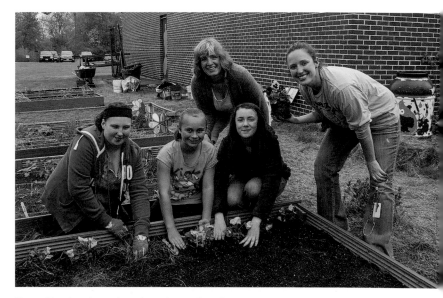

Stacey Purslow (center) with teacher and students at a Farm to School training in Seabrook

New Hampshire Gleans was added to NHFTS in 2013. "Gleaning" means to gather unharvested food from farms for donation to area food pantries, soup kitchens, and schools.

Business

MARY ANN KRISTIANSEN | *Executive Director, Hannah Grimes Center for Entrepreneurship*

The Hannah Grimes Center, as its website notes, "educates, supports and assists in the development of successful entrepreneurs and community builders throughout the Monadnock region with the goal of creating a sustainable, robust local economy and a vibrant, healthy community."

In 1991, after earning her master's degree in public administration from New York University and working for J. Walter Thompson Advertising and Merrill Lynch in New York, Mary Ann Kristiansen moved to New Hampshire to start a soap-making business. She established the Hannah Grimes Marketplace in 1997 to sell locally made products

and developed the Hannah Grimes Center for Entrepreneurship in 2006 to support the growth of local small businesses, of which farming is one.

Retail

Rosemary Fifield | Director of Education, Hanover Consumer Cooperative Society

The Education Department at the Hanover-Lebanon Co-op provides information to help consumers make better choices in the areas of nutrition, food sources, food

Mary Ann Kristiansen with Jillian Miner at the Hannah Grimes Marketplace, Keene

Agriculture

AMY OUELLETTE | *Program Team Leader, University of New Hampshire, Cooperative Extension*

UNH Cooperative Extension programs are established under the guidelines of the University of New Hampshire as a land grant university. The programs focus on agriculture and science and are unique because, as Amy Ouellette says, "staff members provide current, research-based information to farmers, horticultural businesses, and gardeners, allowing them to make their own informed decisions." As part of her responsibilities, she oversees the popular UNH Cooperative Extension Education Center, which is staffed by volunteers and professionals who answer everyday questions about gardening, trees, and home food preservation. Amy trained under retired extension specialists Bill Lord and Otho Wells, and completed her graduate studies under Professor Brent Loy during the 1990s.

safety, cooking, and sustainable agriculture. It also promotes the cooperative movement through outreach to the community. Rosemary Fifield joined the staff of the Hanover-Lebanon Co-op in 1993 and has been the education and member services director since 1998. Since then, the Co-op has expanded to four stores featuring locally sourced products in every department.

When not in her office at the Co-op, Rosemary writes young adult and women's fiction set in New England. "Providing consumer education has allowed me to indulge my love of writing on the job as well as in my private life," she says.

NAOMI SCANLON | *President, Associated Women of the New Hampshire Farm Bureau Federation*

The Associated Women of the New Hampshire Farm Bureau Federation work to establish an interest in farming and agriculture by promoting education, civic, and social involvement among the state's citizens. The group contacts legislators on important farm-related issues, provides support for the Bureau's educational programs, including "Agriculture in the Classroom," sponsors workshops, and provides networking and social opportunities.

Naomi Scanlon is a partner of Clough Tavern Farm, the home of Two Sisters Garlic. She also raises Scottish Blackface sheep for breeding stock and market. As president of Associated Women, she is overseeing the publication of *Celebrating 100 Years of the New Hampshire Farm Bureau*, which will be ready for the Bureau's one hundredth anniversary in 2016.

Naomi Scanlon with members of the Associated Women of the New Hampshire Farm Bureau Federation on a visit to Ledgeview Greenhouses, Loudon

Janet Wilkinson on the grounds of the Audubon Center, Concord

The mission of NOFA-NH is to "actively promote regenerative, ecologically sound gardening, farming, and land practices for healthy communities; to help people build local, sustainable, healthy food systems."

In 1971 the Northeast Organic Farming Association was started by Samuel Kaymen along with a group of farmers and environmentalists. Since that time it has spawned six branches, including NOFA-NH. The organization serves certified organic and sustainable growers and local and organic food advocates and today has five hundred listings with a thousand members. Farm members need not be certified organic to join.

Janet Wilkinson, its first executive director, is a University of New Hampshire graduate who came to NOFA-NH with a nonprofit management background and a rock-climbing hobby. Her NOFA-NH office, once a dusty storage area, was the original Audubon Society building and was situated in the new, larger Audubon Society complex building.

FARM PRODUCT DISTRIBUTION

JULIE MORAN | *President and Manager,*
North Country Farmers Co-op

According to the North Country Farmers Co-op website, its mission "is to fuel economic development in the North Country literally from the ground up." Says Julie Moran, "By increasing locally grown and consumed specialty foods, our farmers hope to boost agriculture, hospitality, and tourism in the region and create opportunities for many different groups and industries to grow and prosper."

Julie moved to the North Country in 2007 and saw a need for what she terms "a highly independent group of individuals" to work together to increase the supply of locally grown food in the area. As a newcomer to town she found it difficult to make contacts. "I spent most of my time being a cheerleader, a taskmaster, a comrade, and mouthpiece to convince people to do something different as I loudly proclaimed the road to improving the members' triple bottom line of social, environmental, and economical improve-

Nigerian dwarf goats, Apple Haven Farm, Stewartstown

ment." The Co-op now has more than twenty-two member farms and thirty on its customer list and distributes along a 200-mile route to such North Country institutions as Mountain View Grand Resort & Spas in Whitefield and the Margarita Grill in Glen.

left Julie Moran and North Country Farmers Co-op members loading produce into truck, Colebrook

right Julie Moran about to begin her 200-mile distribution route

above Field manager Tasha Dunning and her crew harvesting sweet potatoes, Spring Ledge Farm, New London *opposite top* Sara Zoë Patterson tending the booth for Seacoast Eat Local and the SNAP program at Exeter farmers' market *opposite bottom* Farmers' market and State House, Concord

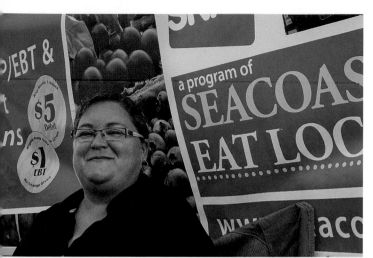

REGIONAL SUPPORT

SARA ZOË PATTERSON | *Coordinator and Board Chair,*
Seacoast Eat Local

According to its website, Seacoast Eat Local "connects people with sources of locally grown foods and advocates eating locally for the health of our environment, community, culture and economy. Through advocacy, organizing, and education, we work toward a sustainable local food system that meets the needs of both producers and consumers."

Sara Zoë Patterson's day job is serving as a librarian and technology integrator for the Portsmouth School District. She has been involved in social justice advocacy in various forms. Her passions of good food and a better future for our planet and its humans come together in her volunteer work for Seacoast Eat Local. In 2014 she spearheaded Seacoast Eat Local's SNAP initiative (food stamps) with access to four summer farmers' markets and is working toward funding the equipment to expand SNAP to the greater Seacoast Eat Local farmers markets. In 2009 she was awarded the Andrew L. Felker Memorial Award for leadership in promoting the growth and prosperity of New Hampshire agriculture.

Acknowledgments and Notes

FROM THE AUTHOR After attending events from Maine to New York's Union Square Market for my first book, *New Hampshire: From Farm to Kitchen*, I established a nonprofit corporation called the New Hampshire Farms Network (www.newhampshirefarms.net). Like the book, the Network features profiles of New Hampshire farms, including their histories, the farmers' agricultural beliefs, farming methods, and plans for the future. From the start, I had certain goals in mind, namely that NHFN remain a nonprofit organization, that it be strictly nonpartisan, and that it not ask for a membership fee. As I traveled the state and visited farms, it became obvious to me that women were playing unrecognized roles in the business of farming. First I noticed that they were always most visible at farmers' markets, where they expertly and enthusiastically spoke about their farm and its product. In delving further into the subject, I realized that appearances at farmers' markets were only the most public face of women's work on the farm. As Commissioner Merrill has demonstrated in her foreword with statistics, all of which most likely are underreported, and as photographer Leslie Tuttle and I have attempted to show in this book, women are vitally involved in all aspects of preserving the New Hampshire family farm. We who love

opposite page Eccardt Farm, Washington

to eat must be grateful to them and their families for their efforts to provide us with healthy and delicious food and a more food-secure community.

FROM THE PHOTOGRAPHER As a photojournalist, I must always decide how much of my own interpretation or aesthetic to put into the pictures I take. It is not possible to achieve an entirely neutral presentation. Some images are intended to reflect more of the photographer's vision than others. What I hope you see in these photos are my deep respect and admiration for the women farmers of New Hampshire and everything they are trying to achieve. I didn't want this book to be just another picturesque rendering of the New England countryside. Rather, I sought to create a tribute to women farmers and the innovations they have implemented.

A lot of thanks and an apology are due: heartfelt thanks to all the women who gave their time, shared their stories, and allowed me to photograph them; and my apology for not showing the relentlessness of their work, the enormous challenges involved in producing apples and cheese, bacon and beef, kohlrabi and kale, and syrup and honey. Without their efforts our tables would not be brimming with healthy choices, our children would not be able to see firsthand how their food grows, and we wouldn't be able to enjoy the true flavors of the harvest.

OUR THANKS TO:

Tom Brody

Larry Susskind

Lorraine Merrill

Steve Taylor

Gail McWilliam Jellie

The women farmers and support groups who contributed to this book

The partners and spouses of the women who contributed to this book

All those working for the New Hampshire Department of Agriculture, Markets & Food—a title that conveys all that is critical to a state's well-being.

HELEN BRODY THANKS:

The New Hampshire Farms Network Board of Directors
and Advisory Board for holding the organization together
while I was completing on this book. They are:

Jessica Boynton

Charlie Burke

Anne Cushman

Barbara Klocek

Ian McSweeney

Gail McWilliam Jellie

Jen Risley

Carole Soule

Janet Ward

Wilma Yowell-Lissner

Christine Zinkand

LESLIE TUTTLE THANKS:

The Creative Ladies—Connie Blaszcyk, Cathie Brenner,
Marcia Hulley, Ginny Mazur, and Jane Pipik—for their
steadfast support and encouragement.

Anne Spirn, for her critical eye.

Farm Resource List

Foreword

Lorraine Stuart Merrill, Commissioner
New Hampshire Department
of Agriculture, Markets & Food
P.O. Box 2042
25 Capitol Street
Concord, NH 03301
(603) 271-3551

The Face of the Farm

Farm Marketers: Center Stage

AUTUMN HARVEST FARM & QUILT STUDIO
Suzanne and Ray LeBlanc
77 Johnson Lane
Grafton, NH 03240
(603) 632-9144
www.autumnharvestnh.com

POVERTY LANE ORCHARDS & FARNUM HILL CIDERS
Louisa Spencer and Stephen Wood
98 Poverty Lane
Lebanon, NH 03766
(603) 448-1511
www.povertylaneorchards.com/farnum-hill-ciders

opposite page Edgewater Farm, Plainfield

STOUT OAK FARM
Kate and Jeff Donald
83 Middle Road
Brentwood, NH 03833
www.stoutoakfarm.com

*Promoting Heritage Breeds
and Heirloom Produce*

YANKEE FARMER'S MARKET, LLC
Keira and Brian Farmer
360 Route 103 East
Warner, NH 03278
(603) 456-BUFF (2833)
http://yankeefarmersmarket.stores.yahoo
.net/index.html

MILES SMITH FARM
Carole Soule and Bruce Dawson
56 Whitehouse Road
Loudon, NH 03307
(603) 783-5159
www.milessmithfarm.com

*Encouraging Year-Round
Buying of Local Food*

HUNTOON FARM
Donna and Phil Sprague
46 Huntoon Road
P.O. Box 77
Danbury, NH 03230
(603) 768-5579

HAZZARD ACRES FARM
Donna Abair
95 Hazzard Road
Springfield, NH 03284
(603) 763-9105

Catalysts for Farm Growth

*Creating Imaginative
Visitor Attractions*

RIVERVIEW FARM
Nancy and Paul Franklin
141 River Road
Plainfield, NH 03781
(603) 298-8519
www.riverviewNH.com

BEANS & GREENS FARM
Martina and Andrew Howe
245 Intervale Road
Gilford, NH 03249
(603) 293-2853
http://beansandgreensfarm.com

*Focusing on a Single
Traditional Farm Product*

TOMAPO FARM
Bruce and Merinda Townsend
Heidi Bundy, Contact
110 Storrs Hill Road
Lebanon, NH 03766-2312
(603) 448-1145

MANNING HILL FARM
Sarah Costa and Sam Canonica
79 Old Manning Hill Road
Winchester, NH 03470
(603) 239-4397
www.manninghillfarm.com

Educating Children,
Adults, and Politicians

F/V RIMRACK AND
GRANITE STATE FISH
Padi and Mike Anderson
Rye Harbor State Marina
1870 Ocean Boulevard
Rye, NH 03870
(603) 343-1500
www.rimrackfish.com

APPLE HILL FARM
Diane and Chuck Souther
580 Mountain Road
(NH Route 132)
Concord, NH 03301
(603) 224-8862
www.applehillfarmNH.com

TWO MOUNTAIN FARM
Kat Darling (pictured)
P.O. Box 197
Andover, NH 03216
2mtnfarm@gmail.com

Building Tourism:
Farm Days, Fairs,
and Food Trails

FARM DAY, WALPOLE VALLEY FARMS
Caitlin and Chris Caserta
663 Wentworth Road
Walpole, NH 03608
(603) 756-2805
www.walpolevalleyfarms.com

THE INN AT VALLEY FARMS
Jacqueline Caserta
633 Wentworth Road
Walpole, NH 03608
(603) 756-2855
www.innatvalleyfarms.com
Jacqueline Caserta and her mother,
Bonnie (pictured)

Fairs and Festivals

CORNISH AGRICULTURAL FAIR
294 Town House Road
Cornish, NH 03745
www.cornishfair.org

NEW HAMPSHIRE SHEEP &
WOOL FESTIVAL
Deerfield Fairgrounds
Deerfield, NH 03037
www.NHSWGA.com

NEW HAMPSHIRE'S WINE, CHEESE &
CHOCOLATE TRAILS
www.visitNH.gov/uploads/pdf/Wine
-Cheese-Chocolate.pdf

LANDAFF CREAMERY, LLC
Doug and Debbie Erb
460 Mill Brook Road
Landaff, NH 03585
(603) 838-5560
http://landaffcreamery.com
Debbie Erb (pictured)

NEW HAMPSHIRE'S ICE CREAM TRAIL
www.visitNH.gov/uploads/itineraries/2014
/ice-cream-trail2014.pdf

BEECH HILL FARM
AND ICE CREAM BARN
Robert and Donna Kimball
107 Beech Hill Road
Hopkinton, NH 03229
(603) 223-0828
http://beechhillfarm.com

Land Preservationists, Working Farmland

Keeping Family Land Productive

PATRIDGE FARM
Mary and Bruce Jones
583 County Road
North Haverhill, NH 03774
(603) 589-5589

MCLEOD BROS. ORCHARDS
MCLEOD FAMILY
Kris Mossey, Contact
749 N. River Road
Milford, NH 03055
(603) 673-3544
www.mcleodorchards.com

Building Food Self-Sufficiency

TRACIE'S COMMUNITY FARM, LLC
Tracie Loock, Manager
72 Jaffrey Road
Fitzwilliam, NH 03447
(603) 209-1851
http://traciesfarm.com

HAYNES HOMESTEAD
Elaine and Haven Haynes
172 Harvey Swell Road
Colebrook, NH 03576
(603) 237-4395

Off-the-Farm Support

AGRICULTURAL MARKETING
FOR STATE GOVERNMENT
Gail McWilliam Jellie, Director of Agricultural Development
New Hampshire Department of Agriculture, Markets & Food
P.O. Box 2042
Concord, NH 03302
(603) 271-3551
www.agriculture.NH.gov/divisions
/agricultural-development/index.htm

Educational Efforts

SCHOOLS
Stacey Purslow, Farm to School
Program Coordinator
Sustainability Institute
University of New Hampshire
107 Nesmith Hall
31 Main Street
Durham, NH 03824
(603) 862-4088
www.sustainableuNH.uNH.edu/purslow

BUSINESS
Mary Ann Kristiansen, Executive Director
Hannah Grimes Center for
Entrepreneurship
25 Roxbury Street
Keene, NH 03431
(603) 352-5063
http://hannahgrimes.com

RETAIL
Rosemary Fifield, Director of Education
and Member Services
Hanover Consumer Cooperative Society
P.O. Box 633
Hanover, NH 03755
(603) 643-2667
www.coopfoodstore.com

AGRICULTURE

Amy Ouellette, Program Team Leader
University of New Hampshire,
Cooperative Extension
Taylor Hall
59 College Road
Durham, NH 03824
(603) 862-1520
http://extension.uNH.edu

Farm Interest Groups

Naomi Scanlon, President
Associated Women of the
New Hampshire Farm Bureau Federation
295 Sheep Davis Road
Concord, NH 03301
(603) 224-19234
https://NHfarmbureau.org

Janet Wilkinson, Executive Director
Northeast Organic Farming
Association of New Hampshire
84 Silk Farm Road
Concord, NH 03301
(603) 224-5022
http://nofaNH.org

Farm Product Distribution

Julie Moran, President and Manager
North Country Farmers Co-op
457 Diamond Pond Road
Colebrook, NH 03576
(603) 726-7992
http://ncfcoop.com

Regional Support

Sara Zoë Patterson, Coordinator and
Board Chair
Seacoast Eat Local
http://seacoasteatlocal.org

Additional Farm Photographs

ALYSON'S ORCHARD

Susan Jasse
57 Alyson's Lane
Walpole, NH 03608
(800) 856-0549
www.alysonsorchard.com

APPLE HAVEN FARM

Patti Craig and Roger Wighton
829 Piper Hill Rd.
Stewartstown, NH 03576

DANBURY GRANGE

Mary Fanelli (pictured)
Blazing Star Grange #71
15 North Road
P.O. Box 77
Danbury, NH 03230
www.danburygrange.org

ECCARDT FARM AND STORE

George, Sandy, Ryan, and Kristi Eccardt
2766 E. Washington Road
Washington, NH 03280

EDGEWATER FARM

Pooh and Anne Sprague
246 New Hampshire 12A
Plainfield, NH 03781
(603) 298-5764
www.edgewaterfarm.com
Sarah Sprague Houde (pictured)

GRAND MONADNOCK MAPLE FARM, LLC

Jillian Miner (pictured with
Mary Ann Kristiansen in front
of Hannah Grimes Marketplace)
149 Breed Road
Harrisville, NH 03450
(603) 547-5497
www.monadnockmaple.com

HURLEY'S HONEY
Kevin and Bonnie Hurley
Carleton Hill Road
Colebrook, NH 03576
(603) 237-9877
*Kevin Hurley pictured with Julie Moran
making the rounds for North Country
Farmers Co-op*

LEDGEVIEW GREENHOUSES
Carolyn and Johnny Carr
275 Clough Hill Road
Loudon, NH 03307
(603) 783-4669

SPRING LEDGE FARM
Greg Berger, Owner
Tasha Dunning, Field Manager (pictured)
37 Main Street
New London, NH 03257
(603) 526-6253
www.springledgefarm.com

STICKS & STONES FARM & CSA
Barbara and Guy Comtois
107 White Oak Road
Center Barnstead, NH 03225
(603) 776-8989
www.sticksandstonesfarm.net

TWO SISTERS GARLIC
23 Clough Tavern Road
Canterbury, NH 03224
(603) 783-4287

WAKE ROBBIN FARM
Abby Wiggin (pictured)
52 Union Road
Stratham, NH 03885
wakerobinfarm.com

WILD MILLER GARDENS
Annalisa and Joel Wild Miller (pictured)
(603) 988-4658
www.wildmillergardens.com

NEW EARTH ORGANIC FARM
Pierre Miron, contact
120 Angels Road
P.O. Box 108
Colebrook, NH 03556
(603) 915-0760
www.newearthorganicfarm.com

PICNIC ROCK FARMS, LLC
John Hodson (owner) and Ward Bird
85 Daniel Webster Highway (Route 3)
Meredith, NH 03253
(603) 279-8421

Additional Resources

NEW HAMPSHIRE FARMS NETWORK
In existence since 2008 and established as
a 501(c)(3) nonprofit corporation in 2014,
New Hampshire Farms Network, without
a cost to the farmer, works to develop a
greater public understanding of the impor-
tance of farming by providing information
about farm histories, working farm beliefs,
and the food farmers grow.
http://newhampshirefarms.net

HANNAH GRIMES MARKETPLACE
Hannah Grimes Marketplace opened its
doors in 1997 on Main Street in Keene. It
draws local customers as well as visitors
and seasonal residents. It features a large
variety of locally made products—foods,
greeting cards, pottery, artwork, jewelry,
and the like.
www.hannahgrimesmarketplace.com

NEW HAMPSHIRE FARM
TO RESTAURANT CONNECTION

The New Hampshire Farm to Restaurant Connection promotes New Hampshire farms and food producers to restaurants, schools, food markets, hospitals, and the public. It has established a Certified Local Program to ensure that local farm products are being used in restaurants.
www.NHfarmtorestaurant.com

NEW HAMPSHIRE FARMER'S MARKET
ASSOCIATION

The Farmer's Market Association is devoted to the improvement and sales of the New Hampshire–based products of farmers and growers in the state and the surrounding geographic area. The Association educates local producers about best management practices and common operating procedures through workshops and seminars.
www.NHfma.net

NEW HAMPSHIRE MADE

New Hampshire Made works to strengthen the awareness and demand for New Hampshire–made products and services and to provide support programs for local businesses.
www.NHmade.com

NEW HAMPSHIRE TRAVEL
AND TOURISM

Travel maps, an event calendar, and a list of historical sites, parks, and attractions are among the resources you will find here.
www.NH.gov/visitors

RUSSELL FARM AND FOREST
CONSERVATION FOUNDATION

This foundation focuses on and provides assistance in conserving and supporting active sustainable farm and forestland in New Hampshire. It prioritizes support for the protection of critically important soils and local economically sustainable farms.
www.russellfound.org

WOMEN'S RURAL
ENTREPRENEURIAL NETWORK

Since 1994 WREN has been helping people achieve greater economic security through entrepreneurship. The organization provides entrepreneurial classes and events, in-depth business development programs, and other opportunities. The organization also sponsors farmers' markets in Berlin and Bethlehem. The Local Works Marketplace provides an outlet for selling locally made products.
http://wrenworks.org

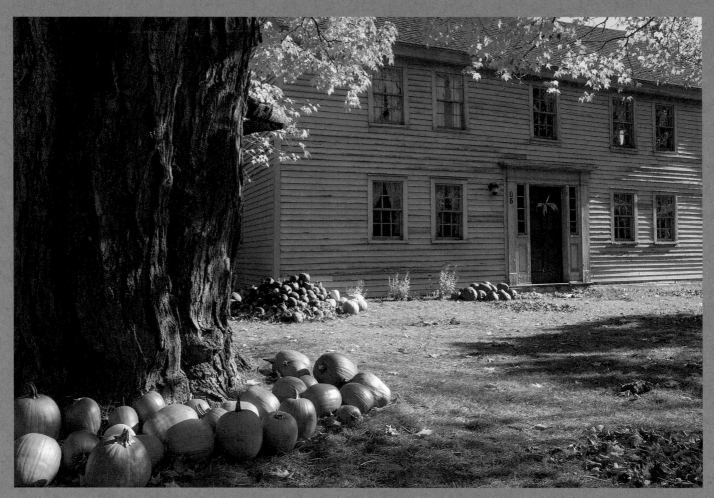

Picnic Rock Farms, Meredith

Index

Page numbers in *italics* indicate photo locations in addition to text discussion.